PHILOSOPHY
OF
PHOTOGRAPHY

PREVIOUS VOLUMES

Volume 1:
Els Vanden Meersch.
Paranoid Obstructions (2004)

Volume 2:
Hilde Van Gelder (ed.)
Constantin Meunier.
A Dialogue with Allan Sekula (2005)

Volume 3:
Hilde Van Gelder (ed.)
In the Name of Mozart.
Photographs by Malou Swinnen (2006)

Volume 4:
Jan Baetens and Hilde Van Gelder (eds)
Critical Realism in Contemporary Art.
Around Allan Sekula's Photography (2006)

Volume 5:
Patricia Allmer and Hilde Van Gelder (eds)
Collective Inventions.
Surrealism in Belgium (2007)

HENRI VAN LIER

TABLE OF CONTENTS

WHAT WE CAN LEARN FROM HENRI VAN LIER

In our times of globalization, real-time communication, and increasing exchanges or mergers between cultures and traditions, it would be an illusion to think that all texts and ideas exist simultaneously and can be accessed freely in the universal library of Babel, aka Google. The introduction of the star system in scholarly thinking, the permanently rebuilt and consolidated Chinese wall of language differences, the necessity of circulating theories in short-cut slogan form, and, last but not least, the need to calculate the use-value of a theory in terms of academic institutionalization, all these elements explain why some texts have been slow to emerge from their first intellectual environment and why it took more than 25 years to finally put at the disposal of the Anglophone reader one of the major reflections on photography that has ever been written.

Henri Van Lier's contribution to the field of photography – and probably to something that goes far beyond it – is comparable, in its scope as well as in its achievements, to the work of the five or six great theoreticians who are being quoted constantly by scholars and readers all over the world: Susan Sontag and Roland Barthes, obviously, but also Walter Benjamin and André Malraux (yes, Benjamin *and* Malraux, despite the current but undeserved disdain for Malraux's ideas on the museum without walls), and, to a lesser extent for their main focus was not exclusively photographic, André Bazin and John Berger. In comparison with these authors, Van Lier is both analogous and different. Analogous, for he too is trying to sketch what he considers being the medium-specificity of photography. Different, because this fascination with medium-specificity does not prevent him for having an all-embracing view of the medium as well as of its position and function in human and social life. Much more than his fellow theoreticians, Van Lier succeeds in *Philosophy of Photography* in combining an astute sense of the detail (which he has developed extensively in his other book on photography, unfortunately not yet available in book form in English: *Histoire photographique de la photographie*[1]) with an extremely broad interest in the meaning of the medium for mankind (for Van Lier, photography is always analyzed in the light of a new discipline he coined as 'anthropogeny' and which studies the gradual emergence of what makes us human through the history of the species). Moreover, having no particular institutional agenda to defend, Henri Van Lier is able to gather a wide range of disciplinary insights and questions – semiotics, history, aesthetics, and, why not, also philosophy – which brings his work close to that of another great 'marginal' thinker on photography, namely Vilém Flusser, whose book *Towards a Philosophy of Photography* (first publication in German: 1983) also took some time before getting translated in English.

The editorial history of *Philosophy of Photography* is almost a novel in itself. It started as a series of lectures in the Museum of Fine Arts in Brussels in 1981 (one year after Barthes's *Camera Lucida*). It then appeared in the *Cahiers de la Photographie* in 1983, before being published as an independent book in 1993, always with the same publisher, which unfortunately went bankrupt some time later. *Philosophy of Photography* continued its mythical but clandestine career until 2005,

when it was republished by Les Impressions Nouvelles (which also offered a new public status to *Histoire photographique de la photographie*). It is now, finally, for all injustices come to an end, offered to a readership outside the Francophone world.

On one point, however, the present edition is radically different from all the previous ones. For copyright reasons, it appeared to be impossible to reproduce in this volume the original iconography of Van Lier's study, which combined a rich mix of (many) very famous and (a few) rather unknown artists. Instead of poorly reusing part of the original illustrations (which were just 'illustrations', i.e. images added in order to give a more visual turn to a theoretical argument, contrary to what happens in *Histoire photographique de la photographie*, which is a set of close readings of specific photographs), it was decided to order a completely new set of illustrations, meant to be more than merely 'illustrative'. Made by fifteen young photographers all trained by the Belgian photographer Geert Goiris, who devoted an open master class to Henri Van Lier's work, all these images represent both an homage to the author of *Philosophy of Photography* and a timely exemplification of the use-value of the ideas defended in the book. Each of the photographers has indeed attempted to suggest in his or her own image(s) the echoes which specific points of Van Lier's work are able to create in the mind, the eyes, but also the hands of contemporary readers and viewers.

This book would not have been possible without the generous support of the Research Platform for the Arts (OPK) of the *Associatie KU Leuven*, which also offered a grant to organize an exhibition and a conference around this publication. We are equally indebted to Geert Goiris, who initiated his students of Sint-Lukas Brussels to the world of *Philosophy of Photography* and whose commitment to this project has contributed largely to its success. Many thanks also to Monica Turci, Donata Meneghelli, Maria Giulia Dondero, Bernard Darras, Marc Lits, Gérard Derèze, Philippe Marion, and Bart Vandenbossche, who participated in various ways in the scholarly preparation of the study of this book, to Rein Deslé and Joke Klaassen, who played a crucial role in the editorial process, to Aarnoud Rommens and Paul Arblaster, our translator and copy editor, and to Mieke Bleyen, the ever-smiling project manager of the whole enterprise. But the first and last person to thank is of course Henri Van Lier himself, whose enthusiasm, intellectual openness, and profound humanity have offered us not only a new way of looking at photography, but also many new ways of understanding the importance of photography in our daily lives. And as we hope to have made clear, this work is now only beginning…

Jan Baetens & Geert Goiris

Notes

1. An online version can be found at the author's website: http://www. anthropogeny.be (English translation by Paola Cook).

TOWARDS A PHILOSOPHY INSTIGATED BY PHOTOGRAPHY

When once the availability of one great primitive agent is thoroughly worked out, it is easy to foresee how extensively it will assist in unraveling other secrets in natural science.

Elizabeth Eastlake, *Photography*, 1857.

A philosophy of photography could be taken to mean the act of philosophizing on the subject of photography. That is to say, one can examine photography on the basis of concepts philosophers have accumulated over a period of two and a half millenia. One could inquire into its links with perception, imagination, nature, substance, essence, freedom and consciousness. The danger of such an approach is the projection onto photography of concepts created long before photography's emergence, concepts which might prove to be ill-suited to it. In effect, many respectable philosophers following this path concluded that photography was a form of painting or minor literature. This judgment was foreseeable since the concepts of Western philosophy precisely subscribe to a pictorial, sculptural, architectural and literary outlook.

But the philosophy of the photograph can also designate the philosophy emanating from the photograph itself, the kind of philosophy the photo suggests and diffuses by virtue of its characteristics. All materials, tools and processes employ, through their texture and structure, a specific mode of constructing the space and time around them. They engage – to a greater or lesser degree – specific parts of our nervous system. They induce certain gestures or operations, while excluding others. As such, they endow those who use them with a certain lifestyle. There is no reason why film, cameras, or photographic paper should be deprived of such action. Undoubtedly, they suggest an unforeseen space and time, a distinct manner of capturing reality and the real, action and act, event and potentiality, object and process, presence and absence, in brief, a specific philosophy.

Self-evidently, the term philosophy is here taken in its most common meaning. A psychology, sociology or anthropology of the photograph would have been equally suitable. And why not an epistemology, semiotics, or indicialogy of the photograph? It is vital to ask what the photograph itself imposes or distills, rather than what *we* demand from it.

This undertaking will therefore be anything but easy. Because not simply our philosophies, but more importantly our languages were originally forged to speak about painting, architecture and literature. On different occasions, God was a painter, a sculptor, an architect or a poet, only because man had been. We therefore do not have the words to describe a photograph adequately. But specialized terminology would be even more fallacious, as only common language has the power – through its *bricolage* – to re-encode itself so as to touch on new objects. That is why one should forget all jargon here, and particularly that of linguistics. When encountering terms such as

signifier and signified, reality and the real, indices and indexes, perception and sensation or act and action, the reader is called upon to rediscover a naive English that will define and redefine itself according to circumstance.

THE TEXTURE AND STRUCTURE OF THE PHOTOGRAPH

Theoretically, one can assume that a certain number of photographs have no other purpose than to unintentionally capture light.
MAX KOZLOFF, *Photography and Fascination,* 1979.

Imagine we set up a photographic camera that automatically takes a picture every single minute. On the photographic film, we would obtain a homogeneous grayish black, more or less chaotic patches and other marks perhaps in the shape of a plant or a partial or entire animal. These are all photographs. Every day, millions like these are taken. Everyone knows that many pictures are interesting scientifically, sociologically, or even aesthetically speaking. There is nothing exceptional about this. Accredited photographers enjoy clicking their cameras without looking in the viewfinder, and the journalist who is able to shoot his celebrity over the head or between the legs of the reporter next to him employs a similar method, especially since the camera is triggered in bursts. We will therefore consider aleatory photographs as minimal instances of photography.

What do we learn from this? That, in a photograph, there are always luminous imprints, that is to say, photons coming from outside to leave a mark on the photosensitive film. Thus, there was an event, a *photographic event*: the collision of photons with the light-sensitive film. *This,* indeed, did take place. To ascertain whether this physicochemical event corresponded to a spectacle of objects and actions, of which the imprinted photons would be the signs to the extent they were emitted by them, is much more problematic and calls for careful consideration. Do I see the reality of past things and actions? Were only a certain number of photons emitted according to an artificial and strict system of selection?

All the inexactitudes in theories of photography can be attributed to the rash overlooking of the strange status of those very direct and physical luminous photonic imprints, which are but the very indirect and abstract imprints of objects. We will therefore attempt to enumerate and describe the characteristics as scrupulously as possible, while keeping in mind that this is the place where everything is played out.

Image p.12: Thomas Verkest, *Evening*.
Image p.13: Thomas Verkest, *Morning*.

I. THE ABSTRACTIVE IMPRINT

Mr. Biot agrees with Mr. Arago that the preparation of Mr. Daguerre will furnish new and desirable means for studying the properties of one of the natural agents that concern us most and that so far we only had few means of subjecting to independent examination through our senses.

REPORT OF THE ACADÉMIE DES SCIENCES, SESSION OF 7 JANUARY 1839.

1. The Photonic Imprint: Weightlessness

The majority of imprints under discussion are the result of an impact, like the tracks of a boar in the mud, or the more or less prolonged material contact with a substance, like stains smudging a cloth. The photon that traverses the optical glass and alters the halides of the film is not really a substance and it does not produce an impact. It carries energy, but has no mass. Indeed, we can also see this when after sunbathing we carry the marks of the bathing suit, transforming us into photograms. The weightlessness of photons endows their inscriptions with a striking weightlessness, almost an immateriality. Tanning is not a form of make-up.

2. The Distant Imprint: Superficiality of Field.

The photons impregnating the light-sensitive film come from light-emitting sources located in a certain volume (the depth of field) and at a distance away from the photographic device, thereby creating a first abstraction. This distant volume is defined by a plane where the reflected or emitted photons have the best differentiation on the film. This is the focal plane – statistically localizable in the result – which creates a second abstraction. The depth of field photons that do not belong to this privileged plane are situated in a space relevant to their loss of differentiation, and the spatialization thus created becomes all the more abstracted the more this loss increases. This loss not only grows beyond the ideal plane but equally on the ideal plane itself. What is called depth of field can equally be called superficiality of field. And superficiality does not say much either, because the word makes one think of a slice or a (histological) section, or of a frame of reference that is insubstantial but can be designated. Considering the evanescence of such a reference, we can only put our trust in an indirect and statistical approach to the plane of high differentiation. If it signals an external spectacle, it can only do so in a very abstract fashion.

3. The Centered Imprint

The photographic imprint is marked off by a margin, which has nothing to do with the frame-trap which, of old, the painter used to focus his environment, or with the architect's active clipping of surroundings. It is quite simple an impassible limit. A lateral and vertical no-more-and-

no-less-than that, in itself, has nothing to do with the direct imprint of photons, and even less with the indirect imprint of the possible spectacle, and that can have no other plastic effect other than on what it contains and not on its exterior, in keeping with the all-powerful ignorance of anything on the outside of the frame. Still, it is necessary to note that this limit is made of rectilinear borders that intersect at a right angle. It could equally have been circular, as the form of lenses suggest.

Undoubtedly, this rectangularity was necessary to arrange the haziness and evanescence referred to above with respect to the depth (superficiality) of field. Be that as it may, our rectangular margin will inevitably integrate certain portions of the imprint while clouding others. The limit is therefore also abstractive, but only in moderation. The frame-limit of the photograph contains neither the violence of sampling nor that of engraving. It is a break without drama on a surface of inscription.

4. Isomorphic Imprints

Photographic photons, focalized by optical lenses according to relentlessly constant deviations, obey continuous equations. This regularity allows the rigorous positioning of their sources, and thus also a prospective spectacle, in accordance with *spatial* coordinates, as can be seen in geological and astronomical photographs. But simultaneously it subtracts from spectacle its local accentuation which would render it a true *place*. Besides being monocular (cyclopean), the photograph is also isomorphic. As it is rigorously spatial, it is always a non-place.

5. The Synchronous Imprint

Also, a photographic imprint can be dated close to a billionth of a second. Regardless of the time of exposure and the moment of impact of each specific photon, their appearance is ultimately datable by the arrival of the last of the photons. In case of a moving source and therefore also a possible spectacle, the succession of incoming photons can never give rise to what has always judiciously been called *movement*. Thus, much in the same way that the isomorphism of lenses and imprints evacuates the concrete place by replacing it with a purely localizable space, the alignment toward the passage of the last photon expels concrete *duration*, substituting it with a physical and exclusively datable time (t_n).

6. The Positive-Negative Imprint: Pulsation

Ultimately, a positive is the *negative of the negative*. From this double conversion, every print retains a hesitance between darkness and light, the opaque and the transparent, the convex and the concave, conferring on the print a kind of flutter. This fluttering or pulsation introduces a new form of abstraction in which the positive invites a reading as negative, and vice versa. This explains our characterization that lacing and engraving are the photographic themes par excellence. And this also explains the particular fascination with backlighting, which is the negative of the negative of the negative.

7. Analogical and Digital Imprints

In the dark and light stains of a figurative photograph, one can recognize forms that share proportions (analogies) with those of an outside spectacle indirectly signalized by the imprinted photons: therefore, these stains are *analogical*. But, at the same time, they are obtained through the conversion of each single silver haloid grain governed by the choice between darkened/non-darkened, that is to say, a choice between yes or no, 0/1: therefore, photographs are also *digital* (calculable). And this digitality, already apparent in all photographic proofs, becomes almost ostentatious in enlarged prints in which the graining becomes flagrant. Once again, what could be naively concrete is the result of abstraction. I clearly see that the Big Dipper, which I perceive analogically, is presented to me solely in the form of a statistically examinable distribution of grains. So much so that, if on this photograph of a region of the sky I fail to recognize a constellation or a well-known or possible star, I can always, as astronomer, numerically (digitally) study the distribution of darker points there to see if there would not be singularities deviating from the expected average value, thus attesting to the presence of possible objects.

8. Surcharged and Subcharged Imprints

In some respects, every photograph is under-informed. If we compare the visual singularities of the spectacle and what remains of it on the photographic imprint, the loss of information will be considerable, while colors (dozens instead of thousands) and lines become a sort of sharpened stains. But, conversely, even a mediocre photograph of the facades I pass every day in my street will reveal, thanks to its immobility and its accessibility to my sight, thousands of things that my perception, unstable and purposeful as it is, had never noticed there before. And this is yet another abstraction in relation to the concrete of everyday existence of these simultaneously filtered and superabundant representations.

If one agrees to accept the eight qualities of texture and structure we have just considered, one may notice that each one in particular and all of them together contribute in endowing the photograph with two apparently opposite characteristics: an extreme spectacular *clarity* in some respects, and an extreme *blurring* in other respects. Moreover, the link between the blurred and the clear is symmetrical: the eventual spectacle always appears in its emergence from the non-spectacle. In other words, information is rendered as emerging fragilely and problematically out of noise, *background noise*. All the properties of the photograph and its functioning are inevitably organized within this polarity and this convection.

2. INDICES AND INDEXES

The seemingly arbitrary cut off of faces by the margins of the image, the forms created through overlapping vistas, the asymmetrical and centrifugal patterns, the juxtaposition of active and empty masses - these qualities constitute the visual definition of what for the most part has been termed the "photographic look".

SZARKOWSKI, *Looking at Photographs*, 1976.

What status do photographic imprints have, then, in regard to a possible spectacle? Are they signs? Or indices? Language is of great help in this matter as it differentiates between signs (*signes*) on the one hand, and indices (*indices*) and indexes (*index*) on the other. We will take up these distinctions as they are very useful in our discussion.

SIGNS are intentional, conventional and systematic signals. They *designate* in the strong sense of the term. Paintings and sculptures are *analogical* signs, because they designate their designated according to a certain proportion (analogy). Words, numbers and punctuation marks are *digital* signs, because they designate their designated by labeling the latter in accordance with a system, and because this labeling follows a sequence of numbers (digits), which is ultimately reducible to a choice between 0 and 1. INDICES are not signs; they are the physical effects of a cause they physically *signalize*, either through *monstration* – as when the imprint of a boar's paw shows this same paw – or *demonstration*, as when an unusual disarrangement of objects might reveal a thief's route to a detective. Indices are non-intentional signs, and are neither conventional nor systematic, but physical. Lastly, INDEXES indicate objects much in the same way the index finger or an arrow might point to an object. These are outright signs, as they are intentional, conventional, and systematic signs. Moreover, they are minimal signs since they designate nothing by themselves; they merely *indicate*.

These specifics suffice to draw attention to the fact that photography does not belong to the realm of signs, as is the case with drawings or words (even considering that one can photograph drawings or words). On the contrary, photonic imprints are precisely indices that *signal* their cause, i.e. the spectacle, either through monstration, as when dark and light stains might reveal a deer, or through demonstration, as when a statistical distribution of blackened points allows one, through reasoning, to discover a heavenly body or the weapon of a murderer for instance. Finally, indexes can *indicate* certain privileged parts of imprints, and therefore also accentuate or orient photographic indices. Such indexes are well-known. It concerns, for instance, the darkening or brightening of certain parts of imprints during development. Or the choice of film, printing, or diaphragm, showing that one attempted to draw attention to morning or evening light, or to the grades of shade of the undergrowth. Or the specific enclosing of a motive through a certain depth (superficiality) of field. It also concerns all the modalities of framing. For one must keep in mind that there are two

types of framing in photography involving completely distinct effects: a) a *frame-limit*; this is characteristic of every photograph due to the simple fact that its borders are straight and cut at right angles; b) a *frame-index* or *framing (centering)*, which possibly foregrounds, indicates or signals particular parts of the print, and therefore also specific indices.

What is exceptional in the photograph when it includes indices and indexes is that the latter maintain an extremely *intimate* relation. Of course, I can simply index a photograph from the *outside*, either roughly by writing an arrow over it, or subtly trough the inclusion of a mark on the photographic film or by maintaining its winding grooves as pointers. But true photographic indexes such as framing, brightening, darkening, depth of field, and so on, signal indices *from the inside,* whose texture and structure they accentuate and orient.

Thus, indexed most intimately, photographic indices are all the more powerful as they are *facial,* that is to say, they present the spectacle from the side normally seen by the viewer, and by preserving the plane (however summarily). And this is by no means trivial. For the imprint-index that a boar leaves in the mud shows a concave for a convex, and the imprint-index of the Turin shroud is reversed left to right, in the same way as the handprints on the cave walls of Pech-Merle. The imprint-index of a shadow on a wall fuses front and back through its purely negative cut. By contrast, the photograph, in that it makes me see the effects of a cause according to a direction and plane by which I ordinarily perceive such causes, provokes, through these effects, my mental schemata into movements very similar to those that gave rise to the cause in the first place.

In this case, it is tempting to say that indices *denounce, betray, reveal, declare,* and *make public* their own causes. However, the slightest excess of vocabulary would be fatal here, because it threatens to obfuscate what is most specific to the photographic index, namely its terrible *muteness,* which one is in danger of confusing with the eloquence of signs. We must therefore content ourselves with speaking of monstrative (and demonstrative) facially accentuated and oriented indices.

In the preceding chapter, we saw that luminous imprints introduced the paradox of being simultaneously the clearest and the most blurred. We can now ascertain that its semiological, or rather indexological status is by no means more reassuring.

The photograph is made up of indices. Therefore, its unity of construction and reading is not the decision of the *trait,* which is characteristic of signs, even of those in China or in caves, but of the *littoral.* In the photograph, the trait is always but the extreme case of rectilinear or curvilinear elongation of the littoral. And this renders its interpretation floating.

Consequently, when and at what point are indices to be distinguished from their background noise? And are they ever truly distinct? Is it not better to say that indices are in continuous *overlap* and in a situation of problematic *emergence* from their background noise? Furthermore, how can one enumerate them? Are there ten, a hundred, or a thousand on the photographic film of a celebrated journalist or even an inattentive amateur? Photographic indices are difficult to delimit, and they are always uncountable.

Of course, they are signaled, accentuated, and orientated by their indexes. But precisely what relations hold between the photographic indexes? Do they assume functions well-defined enough for us to speak in terms of a syntax or a code of indexes? Or do they rather intentionally and conventionally organize indices solely according to broad and floating aggregates, as is the case in rhetoric? Due to the floating quality we have mentioned above and to which we will return, it seems more apt to speak of a *rhetoric* of the index.

But there are less naive oddities. In view of that, the indices of any photograph echo their cause (their possible spectacle) through *monstration* and *demonstration*. This engenders a permanent ambiguity within the gaze, even when we do not think of it explicitly. On the other hand, the monstration effected through the photograph is simultaneously *facial* and *distant*. And, once again, the facial and physical character of the imprint-index makes something appear, but at the same time its characteristic distance removes me from it: it is not some thing that has touched the film but only photons that have touched this thing and the film, thereby only remotely and very abstractly linking both. And to this bifurcation of space (being there, not being there) a bifurcation of time is added. Since, as the physical effect is there-now, its cause is also there-now, but nonetheless I cannot know any more than that this effect *was* caused by it. All photographs effectuate a terrible tension between what is near and what is distant, between the present and the past.

Concerning the notion of *reference* in photography, its subtlety can be summarized by pointing to three usages of the verb. Signs *refer* to their referent, the designated. Indexes simply *refer*, since they lack the designated (referent) in themselves. At best, indices *are referred to,* which is the case when they are indexed by indexes, as is customary in photography. One might now therefore understand how ambiguous it is to speak of the referent of a photograph – unless we take Byzantine precaution – since indexes are the only signs and factors of reference of a photograph, and since indexes directly point to indices and point only indirectly and extremely fragilely to the signaled spectacle.

In addition, the diagnosis of photographic *destination* is by no means more favorable. First of all, to be veritably destined for an addressee, it helps to have rather firmly established designates (referents), which is the case with signs, but not, as we have seen, of photographic indices. Besides, as everyone knows, a vast number of photographs are made incidentally, at random, or on the off chance. However, even with photographs directly intended for someone, the destination is either predominantly or wholly *extrinsic* to the texture and structure of the photograph itself. In brief, in order to address the status of reference or destination, it is certainly advisable never to speak of the photographic *message*, unless explicitly adding that *delegation (mission)* is extrinsic to the photographic film itself (as when I send a photograph of a citadel to an officer to tell him to besiege it and how to do so), or unless one understands the term message in the sense of an *interpreted signal,* which constitutes a misuse of the term now long since abandoned within the growing field of communication theory.

These are not mere quibbles. Maintaining that the photograph has no referent, or at most very indirectly, does not diminish it. The relation of *reference* specific to signs is preeminently

exterior and conventional. Made up of physical signals that physically indicate or demonstrate their cause, the photograph has an incomparable power. Similarly, to say that the photograph has only weak *destination* in terms of an addresser and addressee, does not deprive it of its force either. To the contrary, it is in order to foreground the photograph's fearful sufficiency; its autarky; the way in which it constantly eludes our grasp.

Photography is an ambiguous word. Graphs, as in writing or drawing, are the human products par excellence; and light, as physical agent, cannot be drawn or described. A photograph is strictly an effect. *Photo-effect. Effect-photo.* This has to be understood in the classical sense in which the effect signals its cause, but is also self-sufficient. A new being, *sui generis*, as efficient as it is indicative.

3. FIELD EFFECTS BEFORE DENOTATIONS AND CONNOTATIONS

Visually, it is the structure of things – space – that is important.
Cartier-Bresson, *Photograph n ° 144.*

One can find in photographic prints – possibly indicial and possibly indexed – the three principal orders that organize the realm of signs. Photographs show particular *denotations* (the neighbor's dog or the murderer's revolver) as well as general denotations (desolate, cool, luxurious, etc. environs). They also show *connotations,* that is to say frames of mind, social or epistemological prejudices of the person shooting the photograph or the (ironic, militant, neutral, aristocratic, populist, bourgeois, Muslim, Jewish, German) mentality of the intended addressee. Often one can find marks of the following type: a flowery tree branch on the foreground is indicative of the genre of the postcard or poster, with its specific denotations and connotations. In any case, regardless of whether or not the photograph is figurative, there are almost always and sporadically at the very least, *field effects.*

As the latter aspect is little-known, let us first focus on field effects within the domain of signs. When Michelangelo sculpts a body with one thigh clearly shorter than the other, we do not perceive a deformed body in a congruent space, but a congruent body within a curved space. When Tintoretto inserts three incompatible planes into a painting according to a given perspective, it is again the word *curvature* that best approximates the compatibilization that our brain effects between these calculated heterogeneities. This also applies to texts. Writings that are now regarded as classics are in fact those in which the same curvatures take place, i.e. curvatures of sounds and rhythms, of paradoxically contrary logical structures, of divergent types of images, and in general of all these instances at the same time. Great moments in music and dance are illustrative of the same compatibilities of incompatibles. In all of these cases we can speak of *field effects,* which are sometimes *semiotic* or *indicial,* often *motorial,* and which are always *perceptual.* These field effects are decidedly not connotations, nor even secondary denotations, nor messages in the proper sense since these all would have to be specific at all times while being absolutely general. Rather, they are "visions", "points of view", or fundamental modes of capturing space-time consisting of *rates* (of aperture-closure, suppleness-rigidity, compactness-porosity, continuity-discontinuity, volume-shifts, envelopment-juxtaposition, and so forth) specific to each individual through which not only Rabelais, Beethoven or Picasso are almost always directly recognizable, but also the majority of individuals, as evidenced in graphology, which studies these field effects in writing. This is an everyday experience, even though Western theory remains habitually blind to it. As Dostoevsky noted, certain people do not attract or repel us through particular messages or social status, but through *inflections.*

In addition, field effects traverse indices, and especially photographic indices. In the photograph, patches of light and shade, of fullness and voids; the convections of noise and organization, as well as the paradoxical disparity between denotations and connotations force the eye and the brain into

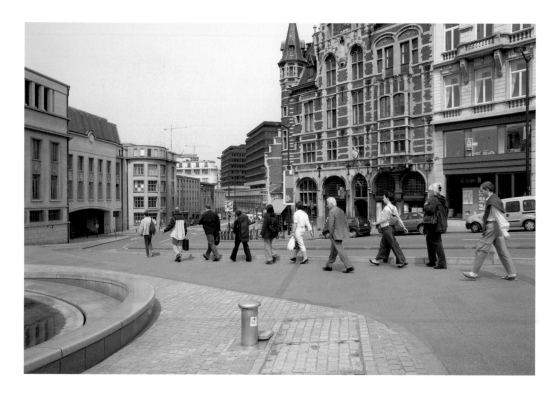

compatibilizations through curvatures and educe general rates of opening-closure, density-porosity, expansion-contraction, etc.

However, from this point of view there is a difference between signs and indices, at least in the West. In its textual and iconic practice, the technological mindset of the West has become so infatuated with denotations and connotations that it often ignores – in practice and almost always in theory – perceptual field effects, except in the case of radical artists, in whose work they are essential. In short, one could say that field effects are intense and rare in Western productions. Yet the opposite holds for even Western photography, where field effects are *not very intense* as the photographic aleatory does not allow their multiplication or complete insertion. On the contrary, due to the same aleatory character, the field effects are *scattered everywhere.* It is precisely in photographs indexed to the highest degree in terms of denotations and connotations that the contingencies of the spectacle, and in any case those of the impregnating photons, often effect the strange curvatures and perceptual, indicial and semiotic inflections of the singular rates of aperture-closure, opacity-porosity, continuity-discontinuity, and so on, in the creases of a dress or a jacket, or in the encounter of the bride's bouquet with the best man's top hat. And this does not even presuppose true indices, which are denotatively and connotatively too revealing, as field effects are often triggered most successfully in those areas of the imprint below the level of the index, thus very close to the background noise.

This brings us back to the differentiation between frame-index and frame-limit. Undoubtedly, denotations, connotations and field effects can be obtained or put to the fore through a judicious frame-index. But one should not forget that the frame-limit, as pure limit, has its own efficacy. Every experienced photographer knows the following exercise: one puts one's eye to the viewfinder, and then slowly moves the latter haphazardly over the environment, at first generally without anything happening, and before long quickly and suddenly, without there being any additional movement promising anything more substantial, it then tightens, curves, bends lightly and constructs compatibilities out of incompatibles. Through the effects of the borders and angles of the frame-limit, denotations and connotations are activated above all when these are embedded within local and sometimes general, perceptual field effects. This entails that one can distinguish two main types of photographs. On the one hand, there are those photographs in which the *frame-index* and its rhetoric is dominant while subordinating both the frame-limit and the aleatory, as can be seen in family, advertising, industrial, and pornographic photographs for instance. On the other hand, there are those photos where the *frame-limit* – the *mobile frame* – is the predominant factor, thus dispensing with the evident rhetoric of the frame-index. This not only concerns photographs taken partially or entirely at random, but also those one usually associates with the so-called masters of photography. Perhaps it would be better to call the latter photographers tout court, as, rightly or wrongly, they remain close to the spontaneity of the photographic process.

Therefore, a photograph is a space of incessant *triggering.* There, denotations, connotations and especially (perceptual, motorial, semiotic, indicial) field effects are set off most vividly and

elusively, the one passing continuously into the other as everything is in overlap and only in problematic emergence from an initial magma. Benefiting from the superficiality of field and framing in particular, indexations can render these triggers outspokenly *centripetal,* as is the case in advertising, pornographic, industrial or family photography. But it is necessary to acknowledge that the spontaneous triggering of photographic capture is ordinarily more *centrifugal,* thereby largely escaping delimitations.

Labyrinths were paths almost always without exits. Photographs can lead to anywhere but lack paths.

Images: p.22-23: Simon Vansnick, *Should the very miraculous of a photographic image consist in the possibility of experiencing beauty in midst of a most everyday, banal and unspectacular street scene made up of a row of 10 coincidental passerby's?*

4. THE NON-SCENE: ON THE OBSCENE IN STIMULI-SIGNS AND FIGURES

Surrealism lies at the heart of the photographic
Susan Sontag, *On Photography*, 1973.

Before all else, the photograph unsettles the scene. Firstly, the *scene* is a specific and marked place that is at a good distance from our eye and body, neither too near nor too far so that we can embrace with our sight what is taking place there. Next are the objects, characters and actions that will manifest themselves in this place with the desired clarity. The scene cannot be found in every civilization, it is lacking in that of Africa for instance. However, in the place of writing the scene was so forcefully introduced by the Greeks, and then penetrated the entire Western history so intensely that it attained a fortunate immortality within a beatific vision, so that, in the eyes of many, photography is seen as undoubtedly invented to stage things and present dramatic or touching scenes even better than in painting.

However, owing to its characteristics as luminous imprint, a figurative photograph offers a kind of *non-scene*. Its depth (superficiality) of field entails that a large part of the evoked spectacle is visibly too close or faraway to be embraced, and that, in addition, it is spatialized in comparison with an abstract plane (the plane of highest definition) rather than occupying a veritable place. Similarly, the frame-limit and frame-index create intervening borders without organic relation to the ensemble or at least to part of the structure of the objects in view. The isomorphism of objectives contributes to the flattening and therefore also the canceling of place. Ostensibly, synchrony crushes duration. The pulsation of the negative of the negative upsets the expected stability of the scene, while digitality presents every trait as present and absent, and while the blend of surcharge and subcharge of information overturns the habitual connections to the surroundings. As soon as we try to actually embrace them as scenes, even the most glorious of photographs – Weston's cypress roots for instance – provoke a feeling of absurdity that gave rise to Sartre's off-scene view of the roots of the *Jardin des Plantes* in his *Nausea*. It is not even very shocking to maintain that every photo contains something obscene through an etymology that, unfortunately, is quite forced, since *ob-scaenus* undoubtedly does not derive from *ob-scaena* (beside the stage), but from *ob-scaevus*, (awkward, of a false prophet).

Simultaneously however, and this still in keeping with the same characteristics of the luminous imprint, the advertising, pornographic, industrial or family photograph presents its objects of spectacle with such an extreme blatancy that we are compelled to introduce the neologism *stimuli-signs*. The *stimuli-signals* of the animal world are well-known. These are signals which, affecting the brain of the receiving organism, set off complex behaviors of nurture, nidification, escape, coupling and so on. These are triggers (*releasers*). Thanks to their superficiality of field, framing, isomorphism, synchrony,

pulsation, surcharge and subcharge, certain imperiously indexed photographs succeed in presenting a stature, gesture, organ or action in such a captivating and intense fashion that the spectator is literally triggered. In this case, one is thus also tempted to speak of stimuli-signals. However, since this effect is only acquired through very forceful indexation, and since indexes belong to the conventional, intentional and more or less systematic field of signs, we will speak of *stimuli-signs*. This would constitute the scene. And yet, in a single blow, that which is presented to us is so immediate, so non-mediated, that within the shock itself there is a loss of mastery, and therefore also a contrary non-scene.

Finally, photo novels might lead us to wonder whether or not the photograph forcefully revives the notion of the *figure,* in the sense of the word prevalent in the 17th century. In this vein, a face is neither an object, nor an action, nor a form. It is a particular way of occupying space, of being alone or with others, of being immobile but being so in a significant way: "to figure" means *to make an appearance, to appear*; and "to figure in" means *to come upon the scene*, according to the OED. The Bible is populated with figures, and Pascal employs in this respect the term "figuratives". The Jewish filmmaker Chantal Akerman created a cinema of figures through a frontal and immobile camera. The same holds for the photo novel, as its characters are not individualities; they do not perform true actions or even movements. They are inexpressive and dead. However, they do occupy space, and this enables signification: standing in a hallway, turned towards an angle of a room, positioned between two animals, waiting in front of a door, sitting down with a distant look, towering over someone else's head, standing on a stage: a true multitude of figures. The textural and structural qualities, which, as we have seen in the previous paragraphs, allow the photograph to carry stimuli-signs, ensure that the photograph will also contain the immobility of figures. In the photograph, these forces of death become sacrosanct. Such is the case with the photo novel, certain publicity photographs, in sequential photography with artistic intention as in the work of Duane Michals, and also in more than one family portrait.

We therefore return to what had surprised us at the beginning of the game, namely that the photograph harbors two contrary effects, which complicates all discourse on the subject. In some respects, the photograph is what is most vague and, in others, what is most clear. However, in both cases the photograph is a non-scene, because sometimes it remains within the obviousness of the scene, while at other times it blinds the latter, through an inverse abstraction.

Image p.26: Sarah Michielsen, *Mine Entry.*
Image p.27: Sarah Michielsen, *Rafke.*
Image p.30-31: Fedra Dekeyser, *Untitled.*

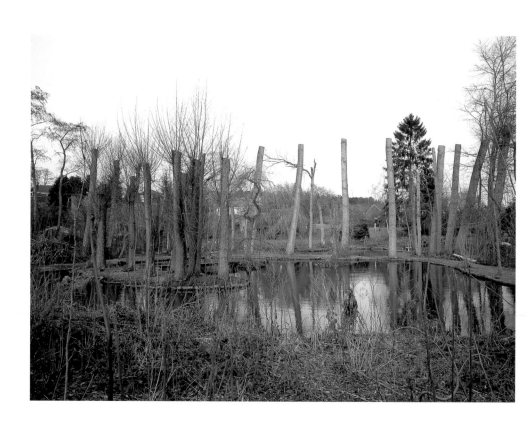

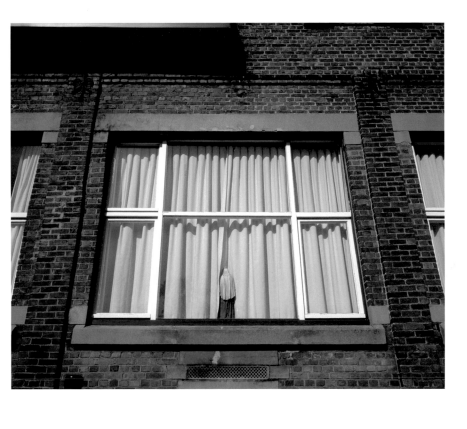

5. REPRODUCTION AND TRANSMUTABILITY: PROCESS AND RELAY

Rather than reproduce the real, photography recycles it – this is one of the key processes of modern societies. In the form of these images, events and things assume new functions and are assigned new significations, thus exceeding habitual distinctions between the beautiful and the ugly, right and wrong, useful and useless, good and bad taste.
SUSAN SONTAG, *On Photography*, 1976.

With regard to sonatas, statues, paintings and texts, one cannot cut or re-cut, brighten or darken, analogize or digitize with impunity. By contrast, the photograph invites and lends itself to all these metamorphoses.

This is due to the photograph's unmistakably digital character, so that, after passing from the state of positive to that of a newspaper print, there is no change of character. This does not hold for paintings, as the latter are analogical from the outset and for which a digitalization of form entails a modification of regime. From its first imprint, the photograph is an impression. Thus, the reframing of a photograph is not inevitably more illegitimate than its framing, regardless of whether it concerns either the frame-limit or frame-index, as both are largely aleatory compared with the painter's picture frame. The photo's subcharge and surcharge of information are such that ablations and additions are often innocent. A non-scene couples easily with another non-scene, which is certainly not the case of a scene in relation to another scene. In addition, infinite indices – in overlap and perpetual emergence from a background in which they submerge – in their turn do not hesitate much to lose or incorporate a number of new companions. On the other hand, might not an object that holds so many successive and discontinuous states (latent images, negatives, positive contact imprints, enlarged positives, printed versions, and miscellaneous layouts) be bifurcated in each of its stages? Put bluntly, one cannot even state that a photograph changes, since it is largely undesignatable. Apart perhaps from its latent image (but who can access it regularly?), is the photograph's *identity* to be situated on the level of its negatives or its prints? According to Stieglitz, what counts most in photography is the printed page. But which one? The print made by the photographer? Many of them do not make their prints themselves. And, even if they did, why restrict it to photographers? While the title of a painting is linked to the here and now of that painting, the title of a photograph only refers to a *process,* which can only materialize across multiple states, and this indefinitely so.

So we return to the idea of triggering, to the click and the release. The click of the guillotine that is the shutter. The click signaling the emergence of the latent image that turns into a negative. The click of the *blowup* by means of enlargers. The click of the scissor's cuts framing and reframing. The click of clashing layouts in the make-up of a magazine. The click of instant multiplication in

0001942

every turn of the rotary press. The click of the eye while leafing through a magazine. The click between the eye and brain when, across memory and perceptual mechanisms, scraps of imprints are interjected amongst other patches of imprints that are equally unclassifiable, thus giving rise to a perpetual recycling. This is thus the most absolute of *disseminations*.

As such, the photograph clarifies certain aspects of information theory. To begin with, it reminds us that one must be careful when speaking of the *degradation* of information through reproduction. Of course, after repeated copying, the number of black-and-white bits contained in a first photographic print cannot but diminish. But information theory also holds that there can only be information in comparison with receptive and selective systems that decide whether things have information value. However, due to the photographic texture and structure, the loss of bits often results in the appearance of overlaps or new indices for the code of the reader. Thus one has to keep in mind that such an exorbitant multiplication of the Same – no matter how reduced – augments the chances of engendering prolific coincidences with other indicial imprints from all parts of the world.

These repetitive triggers and bifurcations, these entanglements and disentanglements, as well as the reciprocal implications of *reproduction* and *transmutability* resemble the fundamental workings of Life. There as well, whether through the recombination of DNA or cerebral memories, processes are repeated and are simultaneously and continuously transmuted billions of times. Over the past thirty years or so, it has become increasingly evident that the one cannot do without the other, which in this case means that recordable transmutations cannot occur without vast amounts of repetition. This entails a simultaneous upstream and downstream movement from the flow of data; the former to allow the unexpected to occur, while the latter ensures that the unexpected is not immediately washed out. As soon as the photograph appeared, its transmutability was felt and implemented in popular media. The *pin board* dissolved and merged in every direction into the photograph. While scanning a *magazine* (the warehouse where one can find everything), photographs slip and overlap, page after page.

Image p.33-34: Roel Paeredaens, *Untitled.*

6. REALITY AND THE REAL
THE COSMOS-MUNDUS AND THE UNIVERSE
THE POSSIBLE AND THE BLACK BOX

A different nature speaks to the camera than speaks to the eye; most different in that in the place of a space penetrated by a person with consciousness is formed a space penetrated by the unconscious. Photographic aids: time-lapse, enlargements, unlock this for him. He discovers the optical-unconscious first of all through it, just as the drive-unconscious is discovered through psychoanalysis.

WALTER BENJAMIN, *Kleine Geschichte der Photographie*, 1931.

After having scrutinized all of its characteristics, it might be said that photography is best understood in light of the opposition often made today between the real and reality. *Reality* designates the real in so far as it is already seized and organized in sign systems, thus assuming the form of intentionally, conventionally and systematically defined signs accordingly distributed in objects and actions, which are the designates that denominate or represent the signs in question. By contrast, the *real* is that which escapes this conception of reality. It is all that is before, after and underneath reality, it is all that is not yet domesticated by our technical, scientific, and social relations, and which Sartre, for instance, dubbed the *quasi-relations of the in-itself.*

Indices hover between the real and reality. They are the chaotic, unnamable and unrepresentable quasi-relations – mostly suddenly – constituting relations: schemas, words, drawings, or digits. From there, they enter into reality, but often only hypothetically, partially and fragilely, in overlap with other possible relations, and consumed by other quasi-relations. In their emergence, indices are not only aided by the internal decision of their more or less analogical or nameable texture and structure, but also by the index which, by designating indices, increases the latter's likelihood to be viewed in a particular context, and thus to be seen as either this or that. Therefore, to start with, *indices belong to the real*, and *only appertain to reality in the final stage*, which is furthermore rarely decisive. Moreover, photographic imprints are indices of indices with respect to possible spectacles. They are (very direct) indices of the imbuing photons, and, through their multiple abstractive mediation, they are (very indirect) indices of external objects and actions. As such, a photograph is not merely a blend of reality and the real. It is a phenomenon where what is represented of *reality* comes to us across the frame of the *real*. Moreover, this is a double frame involving the chemistry of the film and the physicality of the lens. However, the term *across* is still inexact. One has to use the term *within*, since the photograph is infinitely slender and lacks a before or after, back or front. In a figurative sense, photographs are therefore *fragments of reality within the (double) frame of the real.*

It is true that, in the case of advertising, pornographic, industrial, and family photographs, extremely imperious indexes and remarkable analogies may ensure that we forget this frame and can only perceive stimuli-signs. However, even in this case, the *quasi-relations of the real* do not border on the *relations of reality;* the former can be seen as the mould in which these relations are in continuous and precarious germination. This confirms the priority of perceptual, motive, semiotic, and indicial field effects. Indeed, why is it that between the quasi-relations of this matrix and the created fleeting relations there is no solidification at any time, as their place of reciprocal conversions, field effects, curvatures and fluctuations? In a figurative sense, a photograph is *reality emerging from the real.* Conversely, it is *reality gnawed at by the real.*

One can rephrase this by introducing a different set of categories. The Greeks opposed Chaos – non-information and noise – to Cosmos – (cosmetic) order, which was translated almost literally in Latin as Mundus, the cleanly (the non-filthy). In this frame, Chaos pertains to the real, while the Cosmos-Mundus belongs to the realm of reality, of which man could indeed be the ruler and the semiotic epitome, the Microcosm. According to Cicero, Latin had the virtue of introducing a more comprehensive notion, namely that of Universe, the turn-towards-one, capable of embracing Cosmos and Chaos, order and disorder, information and noise, negentropy and entropy, improbability and probability, refinement and obscenity, scene and non-scene. One can now clearly see the place of photography. Through its indexes and certain more or less indexed indices, the photograph offers fragments of the Cosmos-Mundus. However, the chemistry of its latent image and the abstractive configuration of its lenses belong to the Universe World of which they are states. The tips of the Cosmos-Mundus therefore appear as states of the Universe.

There is a third way of formulating this. In ancient times, what mattered most was the *event,* to the extent that, since the times of the pharaohs and of the Romans, many lived for their tomb or posthumous glory, that is to say, for the final consecration of the event that they had been. The *possible,* uncertain event was distrusted. For the most part, the photograph belongs to the latter. The contingency of the photographic shot and its development. The possibility of indicial imprints, and the possibility of indexed indices. The contingency of re-cuts and ulterior layouts. An event implies a certain emphasis, or else value judgment, and willy-nilly seems to refer to some banality. The possible, as situated between imprint and the indicial, between indices and indexes, between reality and the real, between Cosmos and Mundus, is more readily accessible, and, as is the case with a process, is situated in a *course* (things have to run their course, as Beckett would put it) that does not necessarily have an end or goal. Moreover, the latter are even discouraged. Reality is comprised of events and objects while the real is characterized by process and relay.

Therefore, the photograph is in every sense a matter of *black.* What is most important for photography – as with interstellar space – is the night. In film rolls and blank paper, the camera, darkrooms and printing laboratories, it is the night, the darkness and non-light out of which luminous eventualities manifest themselves punctually and incidentally, emerging out of the dark only to return to it. The photographic photon traverses the night of the device only to

take hold again of shadows, in the form of negatives and latent images. And this darkness is contained in a room with its secret and genital workings. Here, one solely speaks of spools, paper impregnators, baths, and developing. The photograph is more uterine than phallic. The architect, the dancer, the painter, the sculptor, the artisan, and the writer all work in a lighted room; even their nights are filled with light. By contrast, the photographer inhabits the *camera obscura,* and he ultimately and always draws in the future viewers with him.

The photograph is even the most vivacious experience of what physicists call the *black box,* where one can clearly perceive the entrance (*input*) and the exit (*output*), without ever knowing quite well what takes place between the two. The function of reality and the cosmos is to dissimulate black boxes, to make us believe that everything can be reduced to signs, referents, objects and events, and therefore to links that clarify and reveal causality. The apprehension of the real and the universe is to dare to confront black boxes wherever they might be, which is to say, almost everywhere when keeping in mind that there are fewer clear-cut cases of causality than what Heisenberg called *series of probabilities.* These series of probabilities are statistically calculable and predictable; however, this does not entail that they are uninterruptedly describable. No matter where it is taken, a photograph renders place and duration, which are peculiar to reality, in the form of space-time, non-duration and non-space, which are characteristic of the real. Invented and used by earthlings, the photograph is the stuff of extraterrestrials.

7. THE TRIGGERING OF MENTAL SCHEMAS

The weight of words, the shock of photographs.

PARIS-MATCH

It is necessary to gauge, one last time, to what extent photography has continuously upset human conduct and behavior. In every civilization, people have always been immersed in environments where mysteries were perceived and were part of everyday life. *To perceive* means, as phenomenology has long since described it, to be in a place for a duration of time amongst objects and events disconnected from a background, according to systems of orientation polarized by *two* eyes, two ears, two nostrils (on either side of the nasal bone, as Bower insists), two arms, two legs, a very mobile head on an occipital spinal column, to which are added different successive layers organized according to the degree of cerebral development (perceptual, logical, semantic schemas), in addition to vast analogical and digital sign systems that are culturally instituted. Perception as elective and globalizing: *per-capere.* What then distinguishes oeuvres that are considered important, those works that are called masterpieces in the arts and crafts? The answer is straightforward: it is due to an intensification, a surcharge of perceptual conditions. From the cave paintings to Cezanne, from the Andean flutist to the Wagnerian orchestra, one can discern intensified and surcharged perceptions that secondarily trigger conceptualizations. Through the curvatures of the trait and the mark, through sonic torsions, through the gathering in the (pictorial, sculptural, architectural, oratorical, choreographic) frame-trap, through the coherence of (perceptual, motive, semiotic, and sometimes indicial) field effects in particular, place is condensed into ubiquity or multi-presence, while duration is condensed into eternity or *Aevum.* Microcosms of the macrocosm. Accordingly, man and his oeuvre were concrete; they had grown together *(con-crescere).* The Greek stage, where thousands of citizens converged in semicircle while focusing on three actors and about fifteen members of the chorus – all of them embraced by the gaze and hearing – was one of the most exigent accomplishments of this perceptual pretension. *Theatre,* a word derived from the Greek *theasthai,* means to embrace by the eye (and the ear) from a fair and equitable distance.

One could say without much exaggeration that the photograph frustrates nearly every property of perception. Of course, on a photographic positive one can clearly perceive bright and obscure zones on white paper. In this respect, the real and reality converge. In the encounter of photons and halides, the real engenders the black spots while reality intimates that these are indeed marks or zones. But this is not really what one thinks about when speaking of photographs and how they are used. The reality that is envisioned appertains more closely to the possible spectacle that these marks and areas bring into view. As we have already noted, this spectacle-reality-there, intensely consumed by the real (by virtue of carrier photons diversely abstracted and filtered), sidetracks the perceptible and creates a kind of non-scene through its superficiality of field, its

matter-of-fact framing, its relentless isomorphism and synchronism, its negative-positive alternations, its ostensible digitality, its informational subcharge and surcharge, and its monocular and cyclopean capture (while paintings, although bidimensional, are binocular, which is surely the case with Cézanne, but also even with Mondrian).

Thus, the most innocent gaze on a photograph creates a decidedly uncanny situation. On the one hand, there is the viewer who sometimes walks around in a gallery but who most often is seated and leafs through a magazine, thus being in a situation of concrete perception. On the other one hand, there is a sheet of darkened paper that is actually perceived, and which signals a spectacle that defies almost all perceptual conditions while displaying space, but by no means a place. Temporally speaking, things are even stranger. The viewer is well and truly enveloped in a duration, and even in an actual *present,* with a consistency characteristic of any present. And the viewer is confronted with an object whose possible spectacle, for its part, lacks all consistence of duration. It is even a provocative instance of pure *simultaneity* as defined in physics: concomitance, at the speed of light, between the emission of photons by the spectacle and their impregnation on the film, the latter datable to a billionth of a second after the passage of the last photon. In other words, all that concerns the viewer takes place in the present, in the Bergsonian concrete simultaneity, while all that concerns the photographic spectacle takes place in four-dimensional space-time, in Einsteinian abstract simultaneity. And the historical debate between these two illustrious men shows to what extent the dialogue was really a dialogue of the deaf.

Consequently, this process cannot really occur between photographic imprints and the body, nor does it occur between signs and imprints. So, where exactly do things happen? Simply put, everything takes place between the print's bright and dark areas and our *mental schemas.*

To clarify this point, and also for historical reasons, it is absolutely necessary to abandon the technical definition of the sign proffered by Saussure, and to use the term in its established

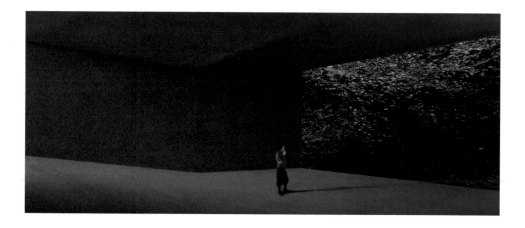

everyday meaning which holds that a sign is a complex of signals designating the designated, an event or an object. Accordingly, one can distinguish six terms that describe this operation of *signification*. Signification takes places between the poles of the sign or designated; an object or event; interpretants, and other signs contrastive with the initial sign, an addresser (sender) and an addressee, and finally – and this is the point that interests us here – between the designator (*désignant*) and the designated (*désigné*), a mental schema. In the world of ancient artisanship, which was dominated by signs and organized in a relatively stable reality, the salient points of this operation were, apart from the sender and addressee, the sign and its designated. We can clearly see that there was a certain mental schematization at work that was so well wedged between and aligned with the designated and the designator (*désignant*) that it allowed one to speak in the singular using terms such as idea, concept, notion, or representation. Thus, everything remained within the boundaries of a cosmos, of a *mundus*.

Even the smallest of photographs upsets this security. The photograph does not contain veritable designators (*désignants*) or signs, nor does it contain a real designated or referent, and it therefore cannot have interpreters (the photograph contains very little reality; it is hardly a universe or microcosm). However, the photographic imprint is often a carrier of indices, and possibly also indexed indices, and is therefore an extraordinary trigger of a mental schema. Or rather, one should say *mental schemas*. Because precisely what these indices reveal is that, in their incessant germination and overlap there are, at every instance, dozens, even hundreds of mental schemas and not just one single scheme. In other words, this means that ideas or concepts are semiotic illusions; they are acts of violence imposed by the desire of reality to capture the ever elusive real. In effect, even in sign systems, the unity of concepts or ideas cannot be but illusory. When I say "sugar", whatever may be circulating between the sign and object is by no means a simple thought but a crossroads where a host of notions may be activated: substance, matter, sweet, powdery, in pieces, crystalline, fondant, sickening, pleasant, bad for diabetes, carbon, sugar bread. In common discourse, speakers incessantly tinker with thousands of mental schemas that spiral and come to fruition, where metaphors and metonymies are not mere stylistic figures. Instead, they must be seen as the fundamental functioning. That is precisely what *artificial intelligence* has made apparent. To be able to use the words "arch" or "to walk", artificial intelligence demands that we define them and that we provide their concepts or ideas. Thus we get underway, believing that a few well-chosen semantic traits would suffice. But three pages of semantic traits will still not allow any A.I. to understand or to imagine what we mean with the phrase "The triumphal arch tilts without threatening to topple", or, more decisively in "Mark walks with difficulty", or simply "Mark is walking". The designators (*désignants*) "arch" and "walk" attain their designated only through multitudes of mental schemas, and this works analogically rather than digitally (which is the only way of managing this worrying plural). What artificial intelligence forces us to acknowledge in the domain of signs, the photograph shows us more naively with respect to indices. The photograph attests to the illusory nature of stability and meaning. During those bygone eras that favored reality, the designator (*désignant*), the designated (referent), indices,

and the indicated emerged. In our present scientific information society, as transfixed by the real, mental schemas emerge in signs and indices. These schemas intervene in signs and indices, as we grapple with both reality and the real. However, their activity is more obvious with indices and the real than with signs and reality. And this explains why linguists and semiologists have missed the cue as they failed to spot the swarming plurality of these schemas.

Surely it is this prodigious triggering of mental schemas one has in mind when referring, rather joyfully, to the *fantastic* in photography. As is repeatedly pointed out in this respect, photography only marginally satisfies the *imagination* as it deceives perception and designation: one imagines *within* or *in front of* a painting, architecture or a text. By contrast, the photograph does not have a within, nor does it even have a threshold. The fantastic added a new and different experience to the imagination of the past. With Hoffmann, it will explore the "supernatural", which is not simply the intensification of our duration and place as was customary in ancient narratives. By the end of the 19th century, stories will take great pleasure in exploring the more inhuman aspects of science. The encounter of photography with the real, and therefore also with science and science fiction, is linked to the fantastic, and as such it is also connected to surrealism in so far as it is associated with our understanding of the fantastic. Being such an imposing activator of ever-spiraling mental schemas, the photograph is closer to the *dream* than to the imaginary. And that is why similitudes and contiguities – the stuff dreams are made of – draw together the mechanisms Freud spotted in his *Interpretation of Dreams,* namely *condensations (Verdichtung)* and *slippages (Verschiebung).* These are more indicial and semiotic than metaphors and metonymies.

All this allows us to focus on common reactions to photography. One usually *chatters* around a photograph, when passing the family album around for instance, in order to simultaneously dispel the panic of the real lurking underneath and in order to animate a feeble reality. The reading of photographic captions in magazines ensures that with less exertion the same informative, animating and apotropaic functions will be fulfilled. But the most common attitude is *leafing through.* For every captioned or commented photograph, there are dozens that are leafed through. Presently, the overwhelming majority of socially cycled and recycled photographs corresponds to the criterion not of frontal but of *lateral* perception*,* no matter whether the photographs are on the wall or on the page. It is during their perusal that photographs (the plural has its importance) trigger off in the most straightforward and most extensive manner all mental schemas in all directions through the immediate activation of the eye-brain nexus, thereby bracketing the other parts of the body. The *layout* is the staging of this texture and structure. Nonetheless, sometimes photographs are viewed attentively without any ulterior motive, and not because one might uncover clues, as detectives would do, or to discover facial or bodily expressions, as a lover might do. What do photographs provoke? *Interpretations?* As appears from the previous paragraphs, the photograph usually escapes interpretation and decoding, at least if these are understood as the progressive lifting of the veil and as semiotic enclosure. In this respect, Freud is as ill-suited to the task as is Hegel. Viewed as such, the photograph *fascinates* us, rather as a serpent might. The fascinating serpent transfixes us through

its movement from back to front (the intervals of the negative of the negative), and left to right (the lateral overlap of indices). The serpent is not actually perceived by the one who is fascinated and stunned by it. The serpent thus establishes a non-space and non-duration, outside of the imaginary. But the simile, as with all the others that may apply to photography, once again breaks down for the same reason. The snake reveals a depth; it is profundity – its mouth, its gaping stomach: the serpent is depths itself. And must we yet again repeat that the photograph is infinite superficiality, that which cannot engulf us? This is what makes the photograph both dangerous and reassuring at the same time. It is the most mentally fascinating thing there is. Leonardo da Vinci held that paintings were a mental thing, *una cosa mentale*. But in fact, it is precisely the photograph that is *the mental thing*. However, this does contradict da Vinci. All his paintings, and his fascinating *Gioconda* in particular, share the most photographic of characteristics, except superficiality *("Leonardo da Vinci, deep and dark mirror"*, as Baudelaire put it). In any case, the "fascinating" adjective has become all the rage today, and the multiplication of objects and photographic shots is surely no coincidence.

The photograph, while blurring the pertinent terms of signification, and activating mental schemas, the latter concerning indices rather than signs, renders the position of the *addressee* equally floating, a position more emphatically referred to in older works, texts or drawings, even if they only had posthumous aspirations or just spoke to the *happy few*. Undoubtedly there are fans of Marilyn or Elvis who think that the poster of their idol was personally intended for them. However, generally speaking, the viewer of a photograph does not really feel interpellated, but all the more impersonally connected to a process that exceeds him. What affects him is not his entire body or the singularity of sign systems, but precisely his mental schemas, that is to say, that which is more general, more intangible and the least individual. We have already spoken at length of the viewer's indifference to photographs, and his straightforward interest (*"how interesting"* is heard even more frequently than *"how fascinating"*). We attributed this *a-pathy* (non-affection in the stoic sense) to habit, which is true. However, the photograph, like volcanic eruptions, tidal waves, or major droughts creates a more philosophical and radical indifference because of its very texture and structure, which are closer to the impassive real than to impassioned reality, provided of course one can agree that understood in this sense, the real is both impassive and overwhelming.

In *Vendredi, ou, Les limbes du Pacifique,* Michel Tournier imagines the situation of a man living alone for years on a desert island, and who, instead of maintaining a sense of reality through the use of signs and social rituals, as Robinson did before him, begins to perceive the trees, hills, and caverns for what they are in themselves, without much recourse to referentiality. In order to designate this symbiosis of man and his environment, the author uses the term phantasm. The word eloquently recalls the co-incidence (the falling-within-together between subject and object), the a-mediation (non-mediation, non-dialectic), the fascination and the imperative coercion (performative) of the *phantasm* as defined by psychoanalysis. It also hints at how reality might wither in the face of the real, or the event in the face of eventuality, or causality in the face of the black box, or the concept-idea in the face of mental schemas. It cannot be denied that, even only viewed socially and sociologically,

that is to say in the least photographic way possible, the most familiar or sophisticated photographs never stop producing, in our eye-brain nexus, something like a phantasmatization. It is not in Plato's idealistic cavern that one will understand photography. We need to reach Friday's Pacific island.

Image p.40,42: Stefan Tavernier, *Untitled*.

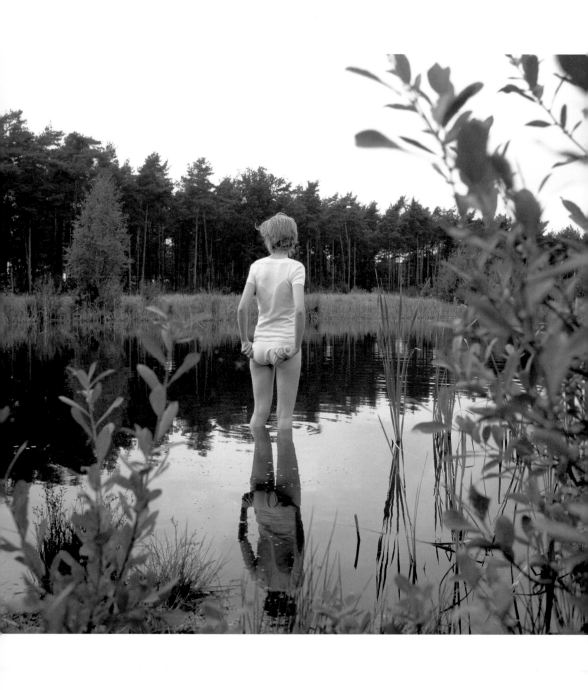

8. TYPES DIFFERING FROM BLACK AND WHITE

A Polaroid hammers into whipped cream.
A Polaroid chisels into transparency.
STEFAN DE JAEGER

Up to this point we have been privileging black and white photographs for reasons of historical and methodological precedence. It is now time to ask ourselves whether other types of photographs share certain characteristics or whether they modify them or develop new ones.

1. The color photograph: symbiosis.

The color photograph shares several traits with the black and white photograph. It is still the alteration of silver halides that provides for contrasts of dark and light, and the colored pigments are articulated following this basic distinction. The color photograph is also a superficial imprint, within a frame-border. It is equally isomorphic, synchronous, a negative of the negative (complementary to the complementary), digital, surcharged and subcharged (about thirty tints instead of thousands), possibly indicial and indexed.

However, certain of these characters are reinforced. In some respects, the colored imprint is more indicial than black and white imprints, since the saturation and luminosity of hues bear indications concerning the seasons and the hours of the day, affective atmospheres, and the chemical states of soil and cultivation in geological or agronomical prints. With respect to stimuli-signs, color improves the speed of recognition and the emotional charge. Furthermore, it even more clearly refuses subtle interpretations specific to sign systems as indexes, which are the only unequivocally semiotic elements of a photograph, are buried under a general warming of colors.

By contrast, color diminishes digitality and reinforces analogy through this warming. It attenuates the effect of the negative-positive interval. The entire motionless side, outside of place and duration, is tempered, because the contrast between advancing warm hues and retreating cold colors creates convections, or even tactile relations. To sum up, the color photograph does not so much evacuate perception, common imagination, or the basic forms of interpretation. The color photograph encourages cruder connotations, and therefore lends itself less to tensions which might engender (perceptual, semiotic, indicial) field effects.

This can be considered an aid, particularly to stimuli-signs in publicity (the case is not so straightforward with pornography). Or, on the contrary, it can also be seen as an impurity with regards to the austerity of the photographic non-stage, and especially as indolence in the search for field effects, the latter being so pronounced in black and white photography. Indeed, for a long time, the most demanding of photographers worked in black and white. But one has come to realize that

there are ways to deprive color of its characteristics. This can be done through outlining contrasts, as Bourdin and Hiro have done. Alternatively, one can make the colors warmer as in Ernst Haas's jerky movements, panoramic shots, and obscene proximities. Or like Helmut Newton, the master of the black overtone in his litho work, who now provides his *contre-jour* shots with color overtones, or by making a virtue out of flatulence – yet another obscenity – as in the work of Irving Penn. And India would never have conveyed its field effects and sweltering heat without Eliot Elisofon's use of color.

Both the familiar and the terrifying are latent in every photograph. Depending on whether black-and-white or color is used, one can come closer to the one or the other. However, this does not determine the results in an exhaustive manner.

Image p.46: Roën, *Sarah's Creek*.

2. The Diapositive: Transfiguration

The lantern slide is so often used as a simple document that one might forget that it has a very original photographic status, and that audiovisual editing procedures that make use of it are not a poor man's cinema, as the South American saying goes.

Unlike the photograph, the slide is not a flat imprint. Rather, it conveys a luminous *flux*. The diapositive dissolves the frame-border and the frame-index, as the surrounding blackness is an ambient and atmospheric shade, belonging to the room where it is projected. This way it does not break contact with whoever is watching and embraces him or her almost architecturally, to the point where he or she becomes a spectator again, and not simply a viewer in an encounter. One does not stumble upon a diapositive as one does upon a photograph, one is bathed in it.

In addition, the slide is *rich*. Here, light does not suffer from fading which usually affects its reflection on the various layers of an ordinary photograph. Filtered through the reversal of the diapositive, the light keeps all its clarity, contrast, and saturation, and hence it retains its general strength of information, while the black tones will be particularly vibrant. In this fervor, digitality disappears to the advantage of analogy, and several aspects of perception are retained or even intensified while guarding synchrony, isomorphism, and the terrible immobility of the photograph. The diapositive *transfigures*.

This paradoxical status, in which perception is stimulated and contradicted, is heightened through audiovisual montage whose slow discontinuity of successive and even momentarily merging views contrasts with the continuity and empathies of the soundtrack. Meyerowitz showed New York City in this way in the Museum of Modem Art. Jespers and Roquiny put together phantomatic sequences of Louvain-la-Neuve by night in the style of Altdorfer, which no other medium – neither cinema, which is too alive, nor photography, which is too spectral (radiographic) – could ever have achieved. And audiovisual montage is equally peculiar to the grasping of structures that are simultaneously fixed and active, as with the *phantasms* of a civilization or a writer.

The slide's power to transfigure poses the question of interpretation or misinterpretation of luminous projections of traditional artworks. Paintings, sculptures, and old architecture already have the character of intensified perception, to which the slide adds the new perceptual intensification of its luminous flux. Thus, the work takes on such an intense air that viewing the original in a museum often disappoints a contemporary audience. Is this a betrayal? Undoubtedly, a diapositive betrays the murality of Gauguin or the depressions of the Maestro dei Aranci. But it suits Rembrandt, who precisely looked for luminous and transfigured materiality. There is a case to be made that with *The Conspiracy of Claudius Civilis*, Rembrandt had painted a diapositive.

3. The SX 70 Polaroid: the Return of the Body

However, the most significant difference with primitive photography was introduced, some years ago, with the Polaroid. Let us get straight to the point by stressing that nothing is more foreign to the body than the photograph, since the former is depth itself, while the latter is superficiality

itself. However, through its various characteristics, the Polaroid rediscovers certain aspects of the body's depth, albeit through a "photographic" distance that agrees well with those contemporary sensibilities that are conditioned by the interconnected specificities of our industrial environment.

To begin with, an SX 70 or a 600 Polaroid camera is a scaled-down chemical plant. Its 7.8 cm by 8 cm picture we have in our hands might be fixed, but it was the place of a development that, slowly and progressively, took place right under our noses, gradually and sometimes unexpectedly drawing out new traces (the subtle lines of the flux and reflux of additives). This chemical, genetic, and aleatory depth materializes in the thickness of the paper and the square format of the picture. The seething and genesis suggests an initial consonance with the body's depth and its anticipations and duration. The Polaroid is anti-instantaneous, and an anti-snapshot.

This is reinforced by the disturbances of the depth of field, or rather the superficiality of field, which is very sensitive in traditional photographs because of their high definition. The low definition of the Polaroid ensures that the imprints of objects and events will effect a vagueness between the distant and the near – the three-dimensional – resulting in a hazy continuity that is tactile as much as it is visual. And all this occurs from a living touch that measures less than it caresses and palpates.

On the other hand, the Polaroid's color saturates and even gets blocked by its borders, in such a way that the latter bulge or drop down – they bleed, as the ceramist or the tiler would say. When one measures to what extent the frame-border of the traditional photograph is cut off and therefore becomes alien to the human body's animal and semiotic anticipation, the Polaroid yet again stands out. By virtue of its squashed borders, it is the entire image – which is already flaky because of its low definition – that tends to camber or cave in. A picture of a neutral environment taken by an SX 70 or a 600 Polaroid is transformed into a phial of light or shade. Its impact will be convex or concave.

These properties define a distinct type of transparency. While the glaze of a photograph endows it with a brightness that volatilizes it, that of the Polaroid creates a cloudy, aquatic, woolly or muffled, stagnant, semi-coagulated depth, whose dominant green renders everything glaucous. This effect may foreground the viscous, at other times it may foreground bronze resonances.

In addition, a Polaroid is woven together like human tissue. In a traditional photograph, the grain of the positive is enlarged and dilated, thus adding a veil to an already slimmed down body. By not introducing such a lateral distension, the grain of a Polaroid reinforces its in-depth homogeneous resonance.

Finally, every Polaroid is non-reproducible and unique. The negative of a photograph is a basic starting point allowing for reprints and infinite re-cuts that in no way alter the initial matrix. While in a manner of speaking a photograph has an 'open' life, that of a Polaroid is closed off and caught in a tireless evolution over which we have no command – we cannot even accelerate the process. The Polaroid thus confronts us with the constant of time, it is an internal world all of its own. This also gives it a thickness, a density and a physiological and sculptural autarky.

All in all, a simple and isolated image of 7.8 cm by 8 cm can of course never capture the movement, anticipations, and the depth of an entire sculptured body. However, it invites us to pay

attention to organs, or those part of the organs (and their tract), that Freud had in mind when he spoke of the pleasures of organs, which are self-sufficient, simultaneously sensing and being sensed, moving and being moved, flesh and sign, and thus an impulse in the rhythmic circulation of pleasure. At that moment, the entire body is but an archipelago of perceptual, motive and semiotic islets separated by gaps without reference points, by black and whites. However, each single one of these islets is a small world.

Thus, what remains is to put Polaroids side by side along a regular pattern, so as to wipe out the white connecting spaces so the curves and inflections of the (perceptual, motive, semiotic, indicial) field effects are intensified, and so that the multiple anticipations and centers – which are equally perceptual, motive, semiotic, indicial – endow an entire body with life. Accordingly, one could rediscover in this veritable *Polaroid frieze* the sculpture of the body, which faded progressively in the course of the 20ᵗʰ century (in part undoubtedly due to the influence of photography), and which Moore and Giacometti were the last to show, the one through emaciation, the other through a dilation fusing sculpture and environment.

From 1979 to 1981, Stefan De Jaeger's compositions were not just idle exercises but Polaroid friezes fully exploring the sculptural. By 1982 he was joined in this domain by David Hockney and numerous others. It is telling that the first work greeting the visitors of the 1982 Paris Biennial was a juxtaposition of Polaroids by the Finnish artist Lyytikàinen, and that its theme was a pregnancy on the verge of delivery. The proximity of Sophie Ristelhueber's twelve black and white surgical photographs eloquently illustrates the contrast between the two media: the immobile superficiality of the latter is opposed to the genetic density of the former.

However, both share the same evanescence of old content. The Polaroid forced us to rediscover something of our bodies, its anticipations, decenterings and resonances. It also draws us into the photographic non-stage, and does not spare us from the slipping away of the securities of the cosmos-mundus in the face of the strangeness of the universe. No matter whether they are black and white, color, diapositives or Polaroids, and even considering different accents, all photographs are *fragments of reality taken through the frame of the real*, with all the paradoxes this entails.

PART TWO

PHOTOGRAPHIC INITIATIVES

What perhaps matters least to a photograph is he who takes it.
GILES MORA, *Les Cahiers de la Photographie*, n° 2.

Up until photography's arrival on the scene, human beings had a sense of mastery and creation in almost every domain. Both artisans and artists were responsible for their project just as much as for the means used in drawing, sculpting, and writing. If the brain had composed a bad model or had chosen ill-fitting traits or words about to be produced, the artist only had himself to blame, and the same can be said of a trembling hand using the brush, chisel or quill. Conversely, successes were entirely one's own. The processing of information taking place in the artist's cerebral cells was proudly called 'spirit'. And an oeuvre's fortunate coincidences – one indeed realized they were there – carried the prestigious name of 'inspiration'.

This system of relations can be summed up by taking a look at easel painting. Sitting or standing, a man held under his domineering view a rather distant model with the canvas in reach. The trajectory from the model to the image was entirely defined by him. Thus, he would remake the world if he was a Romantic, or he would unlock its essence, if he happened to be classicist. In any case, the artist played God, and this explains why he so readily believed in a Creator, a demiurge just like himself. If the painter's canvas or the sculptor's stone were replaced by the writer's paper, nothing substantially changed in the triangle of model, creator and work. As for technology, it was a simple tool, a means in the service of human intentions, the latter alone being really respectable and originary. Instrumentality did not figure amongst the four major causes. It was only mentioned rather shamefacedly.

The photograph radically changed this situation, that is to say, it changed the entire system of traditional culture. This is mainly due to the fact that the initiative of the photographer only takes places *after* other initiatives, namely after those of the technician, of natural light, and of the spectacle with its structures and actors. One is obliged to follow this order of dependency to realize the characteristics of the new system of relations. Man as creator of images, formerly so important and fundamental, has been subordinated and is now often only facultative. With a camera in hand, it is difficult to imagine man as the microcosm, or to exclaim, with Descartes, that 'I think therefore I am' or that, to quote Fichte, 'I am I'. Indeed, we have left behind anthropocentrism and humanism in favor of a more biological, universal, technical, semiotic and indicial perspective. In addition, our attempt at understanding all these incessant mutations has created a techno-logical, cosmo-logical, physio-logical, semio-logical, and indicio-logical mindset.

1. THE INITIATIVE OF INDUSTRIAL TECHNOLOGY

The question is, assuming that the technical proficiency of 35mm camera work were as great thirty-five years ago as it is today, would I still do 8 x 10 work. Is that the question? Well, the answer is, gosh, I don't know. Yes, I think I would. There's such a fascination in, for example, seeing your image although it may be upside down and in reverse on a ground glass. It's an entirely different kind of action. You don't do that with a 35mm now. It isn't big enough to excite you the way it does even on a 4 x 5, certainly on an 8 x 10. It's quite an exciting thing to see. So, I would do all those things. I would underline that they are quite different photographic activities, 35mm and 8 x 10.

WALKER EVANS, University of Michigan, 1971.

Technology has always taken an important initiative with respect to its user. Not only did the introduction of the grand piano allow Beethoven to compose the last of his musical pieces, but the device evoked them to him, it literally put them under his fingers, the same way a Stradivarius or a Bergonzi might drive a violinist or a cellist.

From this point of view, photographers are in a situation similar to that of ancient artisans. Walker Evans is the photographer of the 8x10 inch view camera with its stabilizing and integrating capture. Edward Weston is the photographer of high definition film. Henri Cartier-Bresson: the photographer of "the decisive moment", facilitated by the 35 mm, especially the combination of a Contax f/1.5 lens mounted on a Leica body. W. Eugene Smith: the photographer of the explosive angulosities of the flash bulb, even when working in natural light. William Klein: the master of the wide-angle lens and Ernst Haas, the photographer of Kodachrome 1, who, after some time, made the difficult change to Kodachrome 2, which has a different rendering. These initiatives of technology can lead to remarkable results. At the turn of the century, Alvin Langdon Coburn put into practice the "blemishes" that Bernard Shaw had so eloquently summed up in his portrayal of G. K. Chesterton: *"You could say, if you beg my pardon, that something is amiss with the framing of the head, that something is amiss with the focus, that something is amiss with the exposure time; but that nothing is amiss with Chesterton himself"*. Indeed, nothing was amiss. Coburn explored the possibilities of a black and white in movement, from its dynamist to its futurist effects, until Haas would assemble panoramic landscapes suggested by color. If one were to multiply these examples, it would becomes even clearer that the different technical combinations inflecting the photographic processes of each epoch are divided amongst the classical masters of the history of photography, each one of them pushing the technical possibilities available at that time to their extremes, just like ancient artists used to do. A photographer's "photographic subject", that is to say his systematic exploitation of particular perceptual field effects, is intricately bound to this choice, much in the same way a painter's "pictorial subject" was bound to the props, pigments and media he had at his disposal.

However, a photographer does not depend on his apparatuses and his lenses in the same manner that Beethoven depended on his piano makers, who were few and lived close by. Someone using photography depends on a photographic technician who sees to thousands of individuals all over the world, who in their turn depend on a gigantic *planetary processing,* i.e. photography.

In fact, for every shot or zoom lens, for every film, developer, or fixative to be possible at a given moment in time, it is necessary that at least three conditions are met. Marketing engineers must be aware of the conscious and unconscious desires of a truly international market. Throughout the world, these desires, which often form technically incompatible combinations, must be supplied in compatible combinations whose elements are to be given form by either physical engineers for the lenses, or either chemists, for the film. The moment these combinations are known, their means of production must enter the harsh manufacturing and distributional competition governing the global market. Of course, singular developments might occur, as with Edwin H. Land, who was simultaneously the designer, producer and marketer of the Polaroid. However, even this case presupposes a strong connection between the industrial and the scientific. Land was anything but an artisan. Photography places its users within a multidimensional and planetary technical network, putting the species to work so to speak.

This international process defines a kind of *homo photographicus.* The latter undoubtedly began as a realist. What mattered most was that photographic representations rendered things not as they physically behave, but as they appear to us after perceptual correction. In shade, objects appear bluish, in the morning they are aglow and in the evening they are strongly affected by the colors of neighboring objects. The same column is large or small depending on our distance, and it is straight or curved depending on whether it is located in front or to the sides. Our perception regulates and rationalizes, by painting things in so-called "local colors" (independent of their environment) and according to an orthogonal perspective with "corrected" measuring standards. No doubt, physical engineers and chemists will continue spreading a wealth of ingenuity in order to conform to this non-real and merely perceptual realism by fighting those "distortions" in a spool or barrel lens, and by making use of filters to "improve" colors. Especially in the West, man as technician, as well as technology are thus subordinated to man as user-consumer.

However, the position of a planetary *homo photographicus* also produced an inverse subordination, in which technology, changed by its own logic, modifies the perceptual and mental habits of human beings. An example of this concerns recent cartography, where one can see a photograph coupled to a computer offering geographical and historical positions in curved space that are neither subjected to orthogonal arrangements, nor to realistic colors, nor to recognizable measuring standards. However, we are not disturbed; instead we concentrate and treat it as obvious. Crossing cultural barriers, the photograph, together with other planetary processes such as the computer, sound, the car and the plane, has therefore given birth to a *more topological than geometric* appropriation and understanding that activates mental schemas in an operative rather than conceptual or ideal fashion, where data processing is pivotal and where the real has precedence over reality and realism.

This is even more marked when considering the violent reaction to *Thirteen Portraits of Susan*, put together quite some time ago for the Swedish magazine *X* by Dieter Lübeck, who had collaborated with a dozen research laboratories and about thirty photographers for this project. What we have under eyes here is definitely the result of the physical encounter of a living young woman with various techniques, including radiography, Agfacontour, thermal duplicators, stereophotogrammetry in the treatment of relief, holograms and electronic microscopy for textures, ultrasonoscopy, barograms and thermograms, "owl's eye" multipliers of luminous intensity, and many more. Faced with these structures that by no means intervene in our perceptual world, we are instantly aware that what the devices captured they have indeed seen, and that we will never see it this way, and that even though the devices transmitted them to us, we will never be able to actually perceive these things. We may indeed perceive the imprints, but not the actual spectacle. Perhaps we perceive the spectacle in an "other scene", a non-scene, an anti-scene.

Alternatively, one needs to stress that this limit case only pushes the provocations of ordinary photographs to extremes. We do not even notice the barrel distortions in photojournalism anymore. It is undoubtedly partly due to the fact that our eye-brain nexus makes the desired optical "corrections". But it is surely also the case that the photograph has accustomed us to curved space, where the viewer mentally, through *data processing*, constructs without actually perceiving. The photograph has so incisively changed our epistemologies and aesthetics that Bill Brandt's extreme wide angles, whose photographic shots go well beyond the perceptual powers of the eye-brain couple, have become popular classics. There, the "other scene" runs alongside the everyday scene, interacting in a reciprocal domestication.

The initiative of technology is such that, for almost a century, historians conceived of photography's history as a series of discoveries and technical innovation, until Beaumont Newhall opened new avenues. Even today popular magazines announce alternations to lenses and films not only for commercial reasons, but also in a kind of monthly ritual celebration. Anyone present at a convention of photographers, as if at an ancient Church Synod, could see members of this semi-fraternal and semi-aggressive movement passing around equipment from hand to hand, with everyone touching, weighing and handling it, not so much so as to discover what one already knows, but to participate in a ritual, in a cult. The camera is not an object. It is a *relay* in a process or *network,* just like his acoustic brother, the tape recorder. And the network, as Gilbert Simondon pointed out, has become one of the places for the contemporary *sacred*. As we have just seen, this is but one space amongst many others where the prophetesses speak. We may hear them, but we do not understand.

In the ancient Cosmos-Mundus, of which man was the Microcosm, material and instrumental initiatives were secondary to the extent that they were not considered pertinent to representational systems. In the information-noise and signs-indices of the Universe to which we are exposed, the unrestrained excess of man's technical devices, or more precisely his technical *environment*, which is not merely a means, is more often than not the most pertinent to the system. Besides, what does one mean with *pertinence* when studying luminous, possibly indicial and possibly indexed imprints?

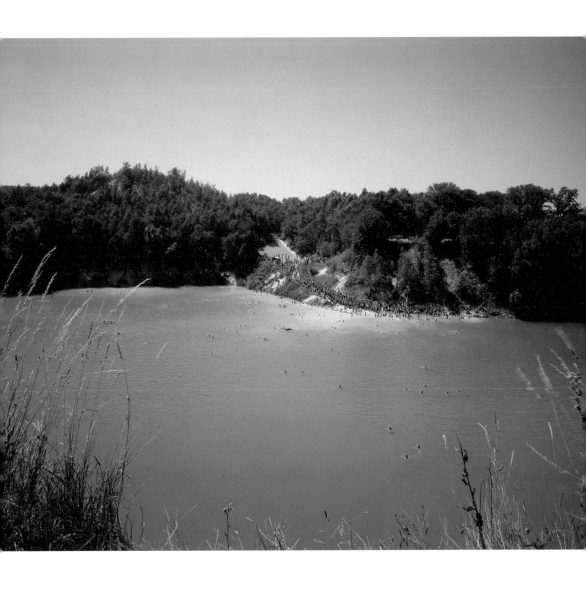

Thus, the photograph is one of three or four spaces – together with sound, lighting, the computer, the car, and the airplane – that manifests the true initiatory character of technology in our contemporary world. In this sense, photography is not only technical, but also technological.

Image p.57: Arnaud De Wolf, *Untitled*.

2. THE INITIATIVE OF NATURE

In temperatures up to 40 million degrees that reign at the core of pre-stellar collapses, hydrogen runs out by being converted into helium, at the same time a gamma ray photon is released. Its energy dwindles at every step, and the photon undertakes its heroic journey: it will take a million years for it to reach the surface and to soar into space in the form of light, visible at last. A star is born.

CARL SAGAN, *Cosmos.*

Nature is at work in all instrumentation. Clocks activate the laws of mechanics, and ink activates those of chemistry. However, in the majority of cases, natural laws are hidden, and all we can see is artifice.

In the photograph, by contrast, light is eminently present and explicit; as such, it marks its own naturalness. Moreover, it unveils nature in its most basic aspects. In fact, light not only has the more or less localized naturalness of water, air or rock. It takes on the structures of the universe in what is most wide and thin, in its transmissions from afar and in its minimal energies. This means that light contains and shows the two cosmic constants, i.e. c and h, coming across the photographer in a pronounced way.

1. Constant c

In its lenses, the photographic process gathers and makes use of the main messenger of the universe, electromagnetic waves. These have remarkable characteristics. Their movement is linear, apart from an enormous gravitational effect. Their refractivity, when passing from one environment to another, is governed by fixed laws. Their interference fringes are continuous and calculable. They are isotropic: in a vacuum, their speed is constant in every direction. According to the theory of relativity, this speed is insurmountable and gives rise to the cosmic constant c. Because of this, simultaneities are created and thus also a coordinated space and time, a space-time. Through the electromagnetic waves between the space-time islets prodigiously moving away or drawing closer, a kind of unity is instituted which ensures that any event belongs to the Universe, to the turn-towards-One. Working on this set of features revolving around c is, for the lens engineer as well as for the photographer, in itself already a remarkable way of connecting with the nature of things.

Furthermore, the solar system privileges particular electromagnetic waves. As the sun's surface temperature is 5800 degrees Kelvin, its most intense electromagnetic radiation has a wavelength of about 2.9 mm (the length of a privileged wave of a black body at 1° Kelvin) divided by 5800, or in other words, 500 nanometers. Thus, Evolution selected the human eye for its adaptation to waves between 400 and 700 nanometers; 500 for green at the centre, 400 for

blue, 700 for red. As a consequence, and in return for other optic capabilities, man captures light in a most balanced and integrating manner. This remarkable ability is one of the elements – together with the standing posture, the hand, the larynx, the neocortex, and the omnivorous diet – contributing to his transformation into the signifying animal, this mammal where analogical and digital signs blossomed, or, in short, humankind as the place where signs originated. The *integrating gaze* is the fundamental practical, scientific, and aesthetic experience bespeaking the concord between humankind and the solar system, and beyond. In other words, these abilities render man the cosmic and universal animal.

Every photographer loves to stress that photographic equipment, with its shutter, diaphragm, lenses and light sensitive film matches the apparatus of the eye, with its eyelids, iris, crystalline lens and retina, which are all organized in accordance with the 500 nanometer wavelength and the isotropy of light. In this sense, the photograph is also solar. However, instead of shaping the Universe according to our Cosmos-Mundus, it opens the Cosmos to the Universe and in some respects dissolves it. Its technical initiatives have shown us that it not only makes use of the concordances between light and the human eye, but also of their conflicts, which forces us to thematize them. Being techno-logical, the photograph is thus also cosmo-logical.

2. Constant h

The photograph is cosmological in a second sense. The moment the light of the prospective (*éventuel*) spectacle crosses the lenses in an undulating and continuous form, and when it reaches the light-sensitive film, discontinuities, granularities and therefore aleatory effects of every kind are introduced. And the vagaries and grains are as fundamental to nature as figural rigidity.

First, halide crystals are in vain placed as regularly as possible in the fixed emulsion on the inflexible base, as their position and orientation can never have the regularity of the light waves that make contact. The crystals are affected by the light waves according to the discontinuities that give rise to a first type of fractionation, or graining.

Chemically speaking, the luminous waves carrying out the transformation of silver grains into black grains of silver, thereby creating the photographic negative, obtain this effect through the injection of luminous energy. However, the latter is a discontinuous phenomenon, unlike waves. As with all energy, it can only appear as a multiple of the second cosmic constant, h; it is granular, corpuscular and *quantic*. The moment the continuous light waves affect the silver halides, they will have, with regards to this crystal, an amount of energy equal to an integer of h so as to be sufficient to induce the transformation, otherwise it is not possible. Crystals are affected discontinuously.

On the other hand, the transformations thus attained in particular crystals are so weak that they will be invisible, and only provide a *latent image*. Therefore, one must make sure that the transformed crystals induce transformations in those neighboring crystals that have not yet been transformed. This operation of colonization is called developing. As it yet again concerns chemical alterations and energy transfers, this action now gives rise to a visible image, the negative, in which new discontinuities join those of the latent image.

As we are still dealing with halide modifications, and therefore also with chemical energy, a fourth granulation will set in that subsumes the three previous ones when the negative is finally inverted into a positive image on paper. This is the grain of the print, the grain we think of first when speaking of a photograph, and which is all the more manifest as it contains further enlargement.

Thus, after having affected the figural continuities linked to the cosmic constant c, the photographic process now thematizes and puts into play the other fundamental aspect of the universe, i.e. its quantic, granular, and aleatory character, and hence also its irreversible modifications, its true historicity, which are all linked to the second cosmic constant h. The successive granulations of shot, developing, and printing give rise to predictable allocations along statistical distributions, but this does not cancel out the figural peculiarities that are triggered by the modifications of a few crystals subordinated to sudden energy jumps in some of the grains. There is hardly a more telling example of how, everywhere and at all times, microscopic events that are insignificant in themselves can give rise to both noise and meaningful macroscopic phenomena, and to possible new directions.

Certainly, mankind also encountered the aleatory in painting and sculpture. The brush thickened, the chisel swerved and the clay showed unforeseen protrusions. But all this was carried over into corrections that were invariably subsumed into an ultimate intentionality. Only the ruin introduced the unforeseen and the crack in ancient oeuvres, and this is precisely what constituted its sacrality. In the photographic process, the aleatory does not depend on human slips or ruin; it is there the moment that the luminous waves granularly affect the halide crystals.

To sum up, one could say that in its exercise of c and h, the photograph connects cosmology and technology so closely that it is undoubtedly the place where artifice and nature, reality and the real interbreed most conspicuously towards a *median reality*, befitting any advanced industry.

3. THE INITIATIVE OF THE SPECTACLE: PHOTOGENICITY

Je est un autre.

Rimbaud

Prior to the invention of photography, the spectacles of nature and culture were limited in number and perceived in an anthropocentric manner. What struck 19th century photographers and their clients was that nature and culture offered spectacles unlimited in number and strangeness. Spectacles are numerous, and include, amongst many others, those of cosmic grandeur (Herschel the astronomer), of medium magnitude *(Geographical and Geological Survey of the Rocky Mountain Region),* of miniscule size (Talbot's botanical and zoological specimens or those of the Bisson brothers), of very brief phenomena (Muybridge and Marey) or underwater (Thompson and later Boutant), of disappearing cultures (Curtis's *The North American Indian*), of unacknowledged social classes (Riis and Hine), of innocent appearances ("Alice" by Lewis Caroll), and also concerning scenes of daily life, as in Rejlander's *Did She* for example.

In all of this, the specific characteristics of every photograph, to which we will return at leisure, and particularly the superficiality of field and the frame-border, ensure that normally unrelated objects, persons and events voluntarily or involuntarily spark off true denotative, connotative, structural, and textural *collisions*, especially the curvatures and inflections of perceptual field effects, where the gigantic and the miniscule enter into an alliance (aerial photography and microscopic photography).

Furthermore, the initiative of the photographic spectacle does not limit itself to simply being present. At any time, men, women, and children, isolated or in group, become *aware* that they are the *theme* of a photograph, and one person will signal his active participation more than the other. The satisfaction is considerable, as being chosen is rare against the backdrop of indifferent city life. It is the pleasure of momentarily being an actor with a minimal public. It is the belief in the magical form of the image within societies that are hardly industrialized. It is the hope of being chosen a star within highly industrialized populations. In any event, the photographed human is not an object. Almost always, even when he is sick or disgraced, he will collaborate with his photograph, as attested by those strange creatures photographed by Diana Arbus. Marilyn Monroe, who was born on film (her mother was an editor), is the perfect example of photography's power of creation, which occurs simultaneously by itself and thanks to the photographic process, and not just thanks to the photographer, even if his name is Bert Stern.

There is more. Even in a conventional photograph, often something will appear that neither the photographer nor the photographed actively looked for or even sensed in advanced. A particular area of a face, a statement in someone's shoulder or ankle, creases in clothes preceding any possible

intention, not to be recovered by any notion of intentionality. If someone who has just been photographed is often so anxious to see what *it*, or *that* looks like, it is because the photographed "I" is always other, unknown and indifferent, always prior to the person photographed. It is the revelation of a truth other than a truth understood as sincerity or authenticity, a truth as old as our existence or even further away in time and space. If this *it* of the photographic spectacle evokes the Freudian *id*, as the codes of analogical and digital signs prior to individuation, it also recalls that of Georg Groddeck, as the pre-signification of the body prior to and below sign systems, revealed through strange correlations that cross cultural evolutions and those of tissues and species. For the photograph, there is no solution of continuity between the spectacle of landscapes, animal, plant, and mineral life, and the stratifications of signs, indices and human bodies. It is the exemplary photographic facet of this stratigraphy of bodies and minds that Richard Avedon explored, right up to that of his dying father.

This etymologically defines photogenicity as the manner in which one is generated by light. (It is the word Talbot chose before Herschel proposed "photography"). Firstly, there is the *immediate photogenicity* of what one easily recognizes in a photograph, without significant deviation from what these things are in everyday life. Secondly, there is the *mediate photogenicity* of what appears in the photograph as the unpredictable zones of the psychological and biological "that" outside of the shot. Finally, there is a kind of *transcendental photogenicity* of those whose appearance boosts the photographic process itself, as with film actors such as Chaplin, whose motility stimulates the cinematographic process as such. It goes without saying that in the latter case, denotative and connotative traits matter less than (perceptual, motive, semiotic, indicial) field effects with their curvatures and inflections.

This introduces three types of *poses*. Firstly, there is the rapid freeze of someone who realizes that he has only to be himself or imagine himself in order to "pass". Secondly, there is the insistent freeze of someone ceasing to picture himself and allowing his organism to let "it" pass. This can be seen in the freezing of action with Diana Arbus, the social role with Sander, and the anthropological sampling of Avedon. Finally, there is the pose à la Monroe, evincing a kind of absolute availability toward the photographic film, photographic paper and the film screen. Here, the only life and even the only "that" possible are those of the photograph as such. This type of photogenicity is perhaps the most philosophical as it shows that there are images that are *a world apart from the world*, in every sense of the phrase. To fully appreciate the derealizing implications of this experience one must take the following expression (which also holds for cinema, but differently) literally: "*it works well on film*".

So everything can be the theme of a photograph, not because a human being is generally interested in everything, which is not true, but because the world creates, for our lenses and film, almost point by point spectacles everywhere, at any time, and on any scale. Thus, the desire grew to experience everything, strictly everything, to see everything from the beautiful to the ugly and the horrible, the face of Einstein as well as that of the idiot, from Julia Margaret Cameron's *Kiss of*

Peace to Michel Laurent's photo of the execution of Pakistanis. One has attempted to see in the manic and ceaseless triggering of shots a form of repetition compulsion, which Freud addressed. This may be the case. However, the infinite object of the photographic can suffice to explain this unquenchable thirst. Walker Evans had to put an abrupt and arbitrary end to his photographic series of the New York subway because he felt his reason sink into the bottomless pit of inventory. Seemingly, the approximately ten thousand negatives alone that Weston had archived at the University of Arizona caused dread because of their vast and at the same time inadequate number.

At the beginning, closely allied to painting, photographers persevered in the composition of their spectacles, either through the use of decors, or by cleverly arranging their characters. In publicity and pornography, one still composes meticulously. Photo novels are series of figures, and artistic "staged photography" displayed its vitality in a recent exposition in Rotterdam. However, these are all cosmological, physiological, semiological and indiciological initiatives of spontaneous spectacles that, up to now, have been the source of the most disconcerting originality. The photograph illustrates Borges's point raised in his *Handbook of Fantastic Zoology*: all the efforts of the human imagination have only with difficulty invented a few hundred species, while nature has created millions, and often stranger ones. In this respect as well, the photograph dismisses reality and drives us to the real.

Image p.64-65: Bart Meyvis, *Crazy People*.
Images p.67-69: Esther Eggermont, *Untitled*.

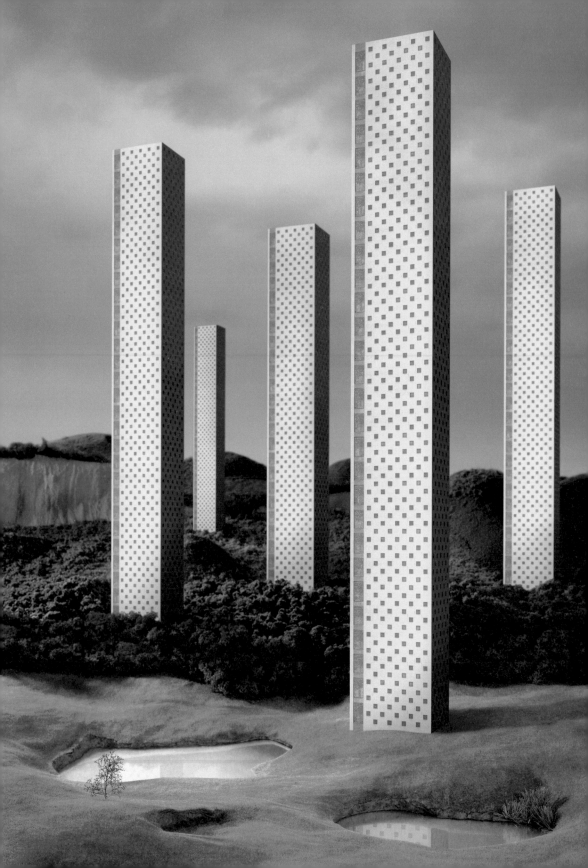

4. THE INITIATIVE OF THE PHOTOGRAPHER: TRAP AND SWITCH MEDIUMISM

> *My best photographs have always been photographs that found themselves. I have*
> *made enough pictures so that now I see like a lens focused on a piece of film, act like a*
> *negative projected on a piece of sensitized paper, talk like a picture on a wall. I know*
> *fairly well how to eliminate accidents from my photographing, and, paradoxically, in*
> *so doing I have also learned that the happy accident can be cultivated!*
> MINOR WHITE, *Found Photographs, Memorable Fancies*, 1957.

Contrary to the painter's initiative, which from the outset resembles that of God, the initiative of the photographer comes afterwards. It comes after the initiative of the spectacle, which follows that of nature, which, in its turn, comes after that of the world-wide photographic process. Of these initiatives, that of the photographer is also the only facultative one. Photographs, even of psychological or social situations, are obtained through the automatic application of objectives, films, developers, and fixatives; they frequently offer interesting or even important results, while texts or aleatory paintings hardly ever do. Still, there are those effects that can only be obtained through the intervention of a human agent, the *photographer*. Both optional and last, and yet miraculous, the photographer undoubtedly has a status even more difficult to define than that of the photographs he makes, or, to be more precise, he *helps to make.*

First of all, this status is not unequivocal because there are photographers of the shot, of developing, of the positive print, printed matter and lay-out. Generally speaking, they do not coincide. Moreover, it is impossible not to take into account this particular "photographer" who is also an artistic director foreseeing existent or possible desires of the buyers of his magazine, and who not only decides which contact print will be kept, but also the lucky one who will become, in this or that shot, *the Berlin child among the ruins* or *the pied-noir returning to France.*

However, when one uses the word "photographer" without further nuance, one mostly thinks of someone taking shots. Like the sexual act, the photographic activity has its stage of arousal, a stagnant phase, a phase of quasi vegetative triggering, followed by the various stages of pregnancy in the darkroom with its techniques of burning and dodging, cutouts and re-centerings, and various lay-outs before reaching a resolution in simple or multiple deliveries. In this metaphor, the moment of the shot is the orgasmic instant. The photograph has its manuals of obstetrics, and its philosophy in the bedroom. The latter thrived the most, confirming the superiority of he who takes the shots. Accordingly, we will now turn our focus on the photographer.

For a particular photograph of an Italian peasant pointing out the retreat of the German enemy to even exist, there had to be Robert Capa. The war reporter, while walking towards the

hill in the background, intuited that the peasant and the American soldier squatting next to him were to form a triangle inscribing itself within the triangle of the landscape. In addition, Capa sensed that the peasant would raise his staff until it would cover a fold of the slope. Thus, in this instant, one cannot decide whether we are merely looking at an individual making a denunciatory gesture or an entire country spewing out the intruder.

The extremely tense concentration required for this type of shot taken in a fraction of a second and at close angle, is known to reporters, but also to those professionals who meet in a scene of Antonioni's *Blow up,* where a photographer is shown who had just snapped away at his model before collapsing on a sofa in a sort of orgasmic exhaustion. This demand culminates with photographers who do not touch up the image and who retain the integrality of the negative, like with Weston's and Cartier-Bresson's focus on the instantaneous, and Cameron's privileging of the pose. This requires *pre-visualization,* that is to say, the capacity to anticipate, in the slightest detail, what the result will be. Cartier-Bresson speaks of his tiptoeing in order to find the most intense angle and what he himself dubbed "the decisive moment". He compares the release of the shutter to a fencer making a lunge. The calling of those who snap away, pick and choose, crop and touch up afterwards and do not wager everything on one single click, is no less passionate, although for other reasons. Sometimes several years afterwards, the latter's old contact sheets will yield new selections according to new codes.

Curiously, a certain modesty prevails in all this hot and cold passion. What is essential to the role of almost every photographer is *vision, photographic* vision. This is a question of registering and not of constructing. One must register not only the collapsing soldier, no matter how emotional this may be, but, more fundamentally, the *encounter* of the elements of the *reality* of the shot soldier with the elements of the *real* of the reflected and subsequently impregnating photons through the anticipation that this photographic imprint will be, after developing and printing, an extraordinary trigger of *mental schemas,* which one can already feel teeming at the very instant the shutter is released. Many photographers state that they have had this vision directly and continuously since childhood. This is telling for two reasons. On the one hand, this does not fully apply to painters, who predominantly paint what they have constructed. If need be, this could confirm the extent to which photographers do not *compose* in the strict sense of the term. On the other hand, the commonness of the photographer's photographic view would justify its everyday nature through the viewer's brief scanning of magazines, while paintings are hung in museums or family shrines.

One has therefore concluded too rashly that the photographer as shot-taker is a 'hunter of images'. The word conjures up *loading, to aim, fire,* and *capture*; to *take, shoot* and *snap*. However, the camera is certainly not a revolver, despite the sound of the shutter and the phallic protuberance exploited in publicity. Neither is it, to keep with this sexual imagery, a suction pump. The camera is rather a *trap* that must lead its prey into getting caught. The photographer as shot-taker resembles the *hunter-trapper*. The trapper is as passive as he is active. For the animal to enter man's scheme, man must take in beforehand the animal's behavior. The word trapper is used by North American

Indians and indicates precisely the complicity between the hunter and his prey as the uttermost brotherhood. The classic trope of the proximity between photography and sexuality is evocative only if one keeps in mind the idea of a reciprocal rhythmic coaptation.

In addition, the metaphor of the trap also indicates that the photographer remains on the outside. The trapper is satisfied with connecting the trap with the prey. The photographer as shot-taker connects the spectacle with the camera obscura. He never sees exactly *as* the film "sees". If the viewfinder is distinct from the lens, the eye sees simultaneously with the camera, but from another point of view. If we are dealing with a reflex camera, the eye sees from the same place as the camera, but at another moment, i.e. prior to it.

All comparisons end here. Ordinarily, the trapper does not adjust the trap to his prey every single minute. But above all, he eats his prey. The photographer as shot-taker is a signalman as well as a trapper. His most essential tasks consist of the measuring of shot angles, incoming curvatures, the amount of aperture, rabatment time, and the intensity of darkness of the shot. And he does not devour his prey. Often, he is a pure predator, *capturing* for the sake of it, knowing that he will only catch shadows – he steals the shadows of others, as Shuji Terayama phrases it. Alternatively, the photographer might *recycle* "mental things" in unlimited and multiform industrial printings. Or he might *accumulate* his traces in photographic collections of Babylonian proportions, *awaiting* endless recyclings. What strange type of hunter-trapper is this who does not even catch his prey but merely its traces? And what to think of 'game' consisting of wild rabbits, the curves of a lover's smile and Orion's nebula?

This elucidates diverse characteristics of widely-known shots. The *bustle* of the family or tourist photographer, whose use of the viewfinder and diaphragm makes us see what could not have been seen without the apparatus, while he can exempt himself of the responsibility of direct perceptual contact with an environment. Then there is the repetition *compulsion* of the voyeur. Or the *professionalism* of those who, fascinated by the initiative of the worldwide photographic process, feel redeemed by obeying it piously and to the letter, like priests or sextons. Or the *availability* of those one could call photographers *tout court*, reporters like Cartier-Bresson or Capa, fashion photographers like Hiro or Avedon, the landscape photographers of *Time-Life,* as well as the "mediums" that, brilliant or not, supply the world's major newspapers and magazines with images and share a respect for the proper textural and structural photographic characteristics, i.e. the overlap of indices, the subordination of the frame-indexes to the frame-indices, uninhibited digitality, field effects preceding denotation and connotation, the aptitude for lateral browsing, the photograph's otherworldliness and anti-anthropomorphism, a reality devoured by the real, even if the most frequent photographic theme remains Man, or *The Family of Man,* as Steichen put it. Finally, one cannot forget the *willingness* of beginners in school gleaning from these attitudes, often supplementing them with the museal and nostalgic aspirations of the traditional arts.

When addressing photographers as such, we can use the word "medium". This is not a misuse of language. Photographers themselves have often repeated that they are not artists in the common

sense of the word. Moreover, they are not craftsmen or laborers. So, where are we to situate them? For the OED, a medium is a person claiming to communicate with the spirits of the dead and reveal the results of such communication to others. For Webster, it concerns a person or thing acting as intermediary, but not between persons and spirits, but between the *world* of men and the *world* of spirits, which is not without link to what we have called 'universe.' If it is true that even a highly indexed and indicial photograph contains fragments of reality against the frame of the real, then every photograph is mediumistic. Innocently or not, both the photographer as developer, printer, and the one responsible for the layout, and especially the photographer as the taker of shots are mediums – *mediums between reality and the real.*

Here, the English language can help us, as *medium* applies at the same time to the object as to the subject, to the photograph and the photographer at the moment of capture, so that both are not quite separable. Furthermore, in its meaning of intermediate, the word medium brings out that, for the photo as well as for the photographer, we are not dealing with mediation or dialectic, which are unifications proper to signs, but only with *go-betweens,* like the interventions of stockbrokers – suited to overlapping centripetal and centrifugal indices – for the most substantial activation of mental schemas.

Image p.70: Tom Goffa, *Rising Landscape.*

PART THREE

PHOTOGRAPHIC BEHAVIORS

As with all other techniques, photography poses the question of the nature of the link between equipment and human activity in general. The humanist illusion suggests that equipment is a means in the service of man, and in his control. However, from the very start, our objects and technical processes are objects-signs, or objects-indices, and we are *signed animals,* literally constituted by them through our languages. Furthermore, devices are not so much a means as a *milieu*; and a milieu we are steeped in rather than it being at our command. In fact, photography nowadays comprises millions of apparatuses and billions of photographs and lenses. It might be we who push the shutter, but, as we have seen up to now, it is, above all, we who are triggered.

There is something peculiar about speaking so extensively of the *photographic act.* One hardly speaks of the musical or chemical act, let alone the automotive or aviating act. One started to speak of architectural acts and the act of writing the moment architecture and literature faded. However, the photograph is in prime health. Why then do we use this curious theological term (God is pure act), which language employs when stressing the interiority of an action (act of faith, hope, contrition) as opposed to exterior ones (the offering of thanks, or thanksgiving), or action and reaction in physics? It is perhaps because it concerns a domain where human action is at once most violent and most decentered, as in the case of the *surgical act* for instance. Both surgeon and photographer cut and trigger. And both operate on the level of living humanity, and engage with a specific death. The one works predominantly with bodies, while the other predominantly engages with signs. Apparently, photography puts us in the realm of the human par excellence, i.e. representation and the graph (cf. *graphein*). Photography appears the most blatantly anthropocentric act, but this is without accounting for what the photographic apparatuses we produce state quite bluntly: *"Put us down somewhere, allow us to release the shutter by ourselves, we will manage to make you something, to produce things often better than you have, which you will never understand absolutely anyhow, as you are concocting mostly anthropomorphic, thus irrelevant theories. And are you even sure you are dealing with representations and graphs? Nothing is more inhuman (indifferent to human plans) than an imprint, no matter how indicial to your eyes, and even though indexed by you".*

Therefore, we will use the phrase photographic *behavior*, without denying the link between the photographic and surgical act, and without failing to recognize that there are scientifically, artistically, commercially, and erotically committed photographers. Following from the indicial and therefore overlapping nature of the photograph, these behaviors will not be as distinct and separable as is the case with sign systems. In addition, it will also prove difficult to clearly distinguish the one who makes the photograph from the one who looks at it. Thus, we will consider them together when addressing the major attitudes or behaviors. Our approach will inevitably be eclectic, and it is in an almost arbitrary order that we will artificially treat each one of these behaviors.

I. PRAGMATIC BEHAVIORS

By pragmatic we refer to anything achieving practical aims in the common sense of the term. As the previous chapters suggest, the photograph has this capacity insofar as, through the exploitation of indexes and superficiality of field, it can function as an imprint-indicial, and especially as a stimulus-sign and as a figure.

1. Moderate Voyeurism

> *Above the table, on which a line of fabric samples had been unpacked and spread*
> *out (Samsa was a traveling salesman) hung the picture which he had recently clipped*
> *from an illustrated magazine and inserted in a pretty gilt frame. The picture showed a*
> *lady sitting there upright, bedizened in a fur hat and fur boa, with her entire forearm*
> *vanishing inside a heavy fur muff that she held out toward the viewer.*
>
> KAFKA, *The Metamorphosis.*

The photograph is the pornographic tool par excellence, provided we can agree on terminology. Let us agree to name *sexual* those objects, texts, sounds and images that supposedly induce orgasmic behavior and which mix, without prior exclusions, bodies and signs. The *erotic* is then that which evokes orgasmic phenomena by favoring the sign extracted from it. The *perverse* is that which splits signs and behavior subject to prior exclusions. The *obscene* is that which brings things back to the side of the sign and its articulation. The *pornographic* is that which intends to provoke orgasmic behavior, or at least orgasmic imagination, in its functioning as a stimulus-sign.

In fact, pornography brings about the textual presentation or imaging of organs and objects which are in part signs. However, pornography also releases sign systems that function to the extent to which they are perceived as sexual, perverse or erotic. At once determinate and isolated, pornographic themes are supposed to provoke an action by themselves, infallibly and independent of all contexts, in the manner a stimulus-sign can trigger a reaction. The fact that the pornographic is widely distributed – often in millions of copies – is supposed to support this automatic character of its power.

There was hardly any pornography in the contemporary sense prior to the nineteenth century. There was only an erotic literature in the work of Rétif de la Bretonne, a perverse literature with Sade, the sexual in the intense plays of Malherbe and the obscene in Rabelais. In the nineteenth century, a behaviorist psychology developed, which facilitated the advance of pornographic themes by maintaining, rightly or wrongly, that orgasmic behavior, even in humans, could be explained by triggers and stimuli. At the same time, industrial production allowed for massive distribution,

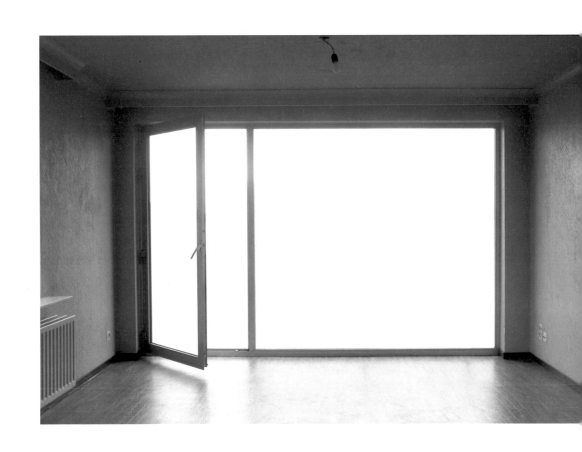

thus guaranteeing effectiveness. So a true *design* of pornographic texts, objects and images was instituted, with real or imagined feedback from the reactions of customers.

The photograph played a decisive role in this development. We have seen that it can organize itself as a stimulus-sign. It is prodigiously multipliable owing to the collusion of its digitality and its printing screens. The photograph's characteristic of image-imprint gives it an advantage over text and even over the sculpted pornographic object, due to the fact that, in the photograph, the "natural" stimulus-sign is seemingly present without "representation". This dictates its specific rules of design. Whenever human figures appear in a photograph, they will necessarily show stereotypical expressions and gestures that have no relation to what actually takes place. If this were not the case, true situations with all their interpretative complexity would be recreated, destroying the effect a simple stimulus might provoke. Moreover, it is important that the layout is not fluid, containing only a minimum of perceptual field effects. These two requirements explain *a contrario* why it is difficult to make pornographic cinema: luminous movements immediately create true situations, that is to say, sexual, erotic, perverse or obscene situations. And it is not easy either to take a pornographic Polaroid, considering that a Polaroid's glaucous (even distant) depth restores a continuity that turns towards the sexual.

Furthermore, pornographic photos have other advantages. Their stimuli, while they are all efficient, are never too numerous. This way, customers can make use of them in a serious or playful manner, according to the mood of the moment. Pornographic photos are the luminous imprints of preexisting spectacles, but which are now arranged according to a superficiality of field and a wholly abstract photonic tactility. Industrial multiplication later confers authority upon the pornographic photograph through the effect of number, while trivializing it at the same time.

In this way, the pornographic photograph lends itself to what one could call a *moderate voyeurism.* In its most intense form, voyeurism is a perversion that in advance excludes certain modalities of touch, particularly that of contact and the reciprocal gaze. However, there is also a less exacting voyeurism excluding nothing, and which often is able to be held in view in order to make the eye-brain nexus function as though there were a remote touch and contact, the kind that takes place among city residents. In addition to a true form of pornography, which can be found in specialized publications, photography has developed a light-hearted sort of imagery which can be found in *Playboy, Penthouse* and *Lui.* More specifically, in these magazines we can find pictures that are not sexual, perverse, obscene or pornographic but only timidly erotic. However, one can also formulate this differently. Present-day scientific and technological society is not particularly perverse. Through the transpositions in which it excels and its absence of substantiality, photography would like to count amongst its social functions that of being the last shelter for perversion, as an important cultural motor. That is, in a suitably neutralized form: a passive and empty perversion.

The rest is a matter of culture. One shouldn't be surprised that the West developed a *horizontal voyeurism,* a voyeurism through the keyhole, in accordance with a situation dear to

Sartre. In sharp contrast, the Japanese, as the descendants of Utamaro, explored all violent and innocuous possibilities of a *protruding voyeurism,* as when someone is hanging upside-down from an alcove while centering himself by the ceiling's beams.

Image p.80: Alexandra Verhaest, *Madonna.*
Image p.81: Alexandra Verhaest, *Medea.*

2. Positioning in Advertising

The Prop's the Thing.
TIME MAGAZINE

The photograph is almost as closely linked to publicity as it is to pornography. Here too, the photograph not only serves but also partly creates and develops as a milieu and not merely as a means.

Firstly, there is *short-term* publicity, which is made for a product or an event without much longevity. It tries to draw attention to something by praising its merits. It is a blend of shock and seduction, thus resembling the photographic mechanisms of pornography. One looks for signs or object-signs that speak by themselves independent of any context. These photos are marked by a rhetoric of overtly decipherable indices, making them look orderly or disorderly, subtle or botched, depending on the audience. Nonetheless, there is a difference with the pornographic image. In the latter, objects are supposed to be "naturally" attractive and stimulating, while "shock publicity" only attracts a particular culture and *target* group. Thus, the use of photographic stimuli-signs in advertising shows a diversity lacking in pornographic photography.

However, large advertising productions do not envisage short-term but *long-term* goals. They concern products, services, political parties and religious groups that expect a long future. What matters in this case is the *positioning* of what is presented, that is to say its distinctiveness, its *difference* within the technical and social network over a long period of time. Long-term publicity not only transmits the positioning of social goods but also performs it. It has as function to signal that what is announced is something distinct from all the rest and more particularly all the other products that belong to the same field. The important thing is not that Marlboro, Kent, Peter Stuyvesant or Dunhill should be appealing; although as cigarettes sold all over the world they clearly are. What is crucial is that they be enticing in a manner different from each other. That is to say, what is important is the distribution of the particular attitude or look of the desire to smoke in a given society at a given period in time. Likewise, it is not a question whether Mitterrand, Giscard, Chirac or Marchais appear as promising – which they, as politicians, are already anyway by definition – but that each one of them is perceived as such in a manner differentiating the one from the other three. This can be done to the point where, by putting together the areas the four politicians occupy, one can almost recover the entire image of France's political desires of the period. How does the advertising photograph have a hand in this operation?

Assuredly, by its *primary denotations,* which we can interpret as having a more lasting effect since they do not simply present themselves as mere stimuli-signs but rather as figures. The *secondary denotations* all pertain to the same order: i.e. youthfulness, at ease, competence, energy and risk-taking. These all belong to moods, to the tonalities of existence. As far as *connotations* are concerned, that is to say, those signs attesting to the frames of mind (hygienist, competitive, traveling) of the transmitters

or receivers, they can be very marked in a political advert or in publicity for a bank, but are less so elsewhere: the Gitane cigarette presents itself as regional and working-class, while Kent and Peter Stuyvesant are presented as international and upper-class, and while Marlboro overlaps these distinctions. Furthermore, the essential aspect of long-term publicity seems to reside in the *perceptual field effects* it triggers, or rather, it institutes. Furthermore, this could explain why connotations are often hardly marked in the case of long-term publicity, and why denotations take the form of figure-signs rather than stimuli-signs.

The positioning of what is announced through perceptual field effects is perfectly exemplified by the cigarette ads of the seventies, just before the stress on nicotine and tar levels evened the circulation of desire. The three international brands most widely sold were divided along three major Western categories, namely space, time and becoming — or, to be more precise, centripetal location, centrifugal flow and the all-out becoming of travel, which apply to Marlboro, Kent and Peter Stuyvesant, respectively.

As for the perceptual field effects retained (indexed) in the photograph, for Marlboro it is that of *closed space,* closed off above and by the background, centripetal and dense, heavily scented and in browns turning red. The direct and indirect denotations, as well as the connotations, are effected by a horse led by a mature cowboy returning home. The text echoes the words: *where* and *country* indicate place, *come to* indicates centripetal movement, *flavor* indicates the smell and a strong flavor in the mouth. In addition, the syntax, in an outspoken centripetal fashion, places Marlboro in between two groups of identical phonemes: come to (kvmt) and country (kvnt), whose repetition and strength are reinforced even by written form, where the central *lb* of Marlboro appears clutched between two groups of letters of equal number: *mar oro.*

By contrast, the photographic field effect of Kent is time as an imponderable and *horizontal flow,* suggested by the pastel tones, dominated by white crossed by evenly horizontal blue and gold lines. With respect to direct and indirect denotation, and with respect to connotation, the photograph shows healthy male and female youths against an aquatic backdrop. Again, the text merely makes the image explicit: *time* (instant), *what a good* (exclamation in accordance with the instantaneity and singularity of the moment), *taste* (the flavor as captured in the moment, not in its substantial density), with two *t*'s playing the role of relay in the sequence t-d-t, th-d-t-t-, kt: *What a good time for the good taste of a Kent.*

Peter Stuyvesant resumes the thesis of place and the antithesis of time, and ends the dialectic by resuming the two in the synthesis of the *voyage.* The perceptual field effects are held within an angle, namely that of the plane taking off, and by the variegated colors favoring the complementary invigorating reds and greens filling the equally variegated and never clear-cut forms (drawing on Rauschenberg's tears). In short, this is a kaleidoscope of a world seen through airports. Regarding the direct and indirect denotation, apart from the plane, it would not be suitable to have clearly defined faces or objects, but only those evoked through a gliding movement (again similar to Rauschenberg). The connotations are subtly colonial. Textually speaking, there is no clear catchword for conveying an

effect that is so unstable, so transitory except to turn to the most kaleidoscopic word in English: *joy*. Any particular message would delimit the voyage. The name is enough: Peter Stuyvesant, evoking one of the founding groups of New York City, i.e. the Dutch, indeed, the Flying Dutchmen – as air travelers.

Similarly, the French elections of 1981 presented the candidates in an almost exhaustive system of perceptual field effects. Mitterrand: shot in *sfumato* and depth of field in front of a wall, lightly slanted. Marchais: his back to a wall and frontal. Giscard: in a frontal shot along the mural plane, with superficiality of field. Chirac: shot in three-quarter compared to the surface and depth. These are the denotations and connotations that arise: Mitterrand's misty look coming from afar and looking into the distance; Giscard's lucid look following the passer-by; Marchais's active look directed towards the one coming to the appointment, and Chirac with his eye on the target. This system was so complete that the other parties could not but be reduced to small parties.

We have elaborated on these examples a bit further because they clearly define the notion of positioning, and also because they show the strict program to which the advertising photographer must conform. The adequate functioning of things is so precarious as to require a duo, and even a trinity: the creative team, the photographer and the artistic director. Based on the *briefing* handed to the creative team who improvised on it, the photographer tries to find suitable field effect, as well as fitting denotations and connotations. However, there is need for an outside judge, i.e. the artistic director, who will decide whether the acquired shots do indeed truly correspond to the positioning. The artistic director must ensure that the shots function at most as variations and do not alter the system of differences determining what is announced. The layout itself is part of a well-defined space-time configuration: profound, stable and warm in Chanel, torn (scratched) in Christian Dior, turbulent in Revillon, baroque in Lancôme.

This allows us to specify the long-term objectives of advertising photography. Surely, it does not aim at being distasteful. It acknowledges that its mission is not to be agreeable or to resort to the proven arsenal of violence and sex. Occasionally, short term publicity makes use of simple techniques. But neither the most arousing negligee nor the most terrifying revolver can do anything for Marlboro, Kent or Peter Stuyvesant or for any of the candidates for the presidency of the Republic. On the contrary, if a female style were to be sterile or harmful to a petrol brand pretending to put "*a tiger in your engine*", it at least must agree with the "*shell I love*", since the shell, the female theme par excellence, is part of the imaginary positioning of a corporation that originally transported sea shells. Thus, at first, long-term publicity does not try to seduce, to persuade, to inform or to embellish, but to make present an actual or potentially interesting difference within the system of products of a society at a given time. Therefore, we should not be surprised by the permanence of long-term publicity, a permanence equivalent to social permanence. The positioning of Coca-Cola has not changed in a hundred years. In publicity, what psychologists call *impregnation* is not a simple relation between form and substance as is the case with animals. In the short term, it concerns stimuli-signs and with

respect to the long term, it concerns figures and even stable perceptual field effects, of which images are only modulations.

When all is said and done, publicity is as ancient as man since man is the signed animal, for whom goods are attractive only when placed in sign systems. The novelty of the present is that publicity within an industrial society is industrial itself. In a technological and commercial network of billions of products distributed amongst billions of customers in a synergic planetary network, publicity requires a cheap prop perceptible to all. Whether in Europe, America or India, this vehicle can only be the photograph, radio or TV. The latter is the most powerful since its images are acquired through the transmission rather than the reception of light, endowing the advertised product with its own energy; the TV image is such as created the Goldorak force. However, the simple photograph also has its virtues.

Due to its fixity, the photograph maintains a close relation to the packaging and the written name of the product, which, in a many cases (as with cigarettes, toothpastes, washing powder, and hand soap) are a significant part or essential to the product itself. On the other hand, it is the advertising photograph that surrounds the city and the streets, and assures the public insertion of certain particularly important products (cars, food and politicians) in the technical network, which has become the foundation of our society. With its light and sound, the billboard now plays a significant urbanistic role. It succeeds even better because it is extremely transposable and because the denotations and connotations are often subordinated to blurred perceptual field effects. This way, the photo establishes local climates, *microclimates,* as it corresponds to an envelopment all architecture aspires to. Having become monument, or having replaced the monument, the billboard signals that in contemporary society great commercial, political and religious products are more important than great men. Unless, in their turn, the latter are great products or great events themselves.

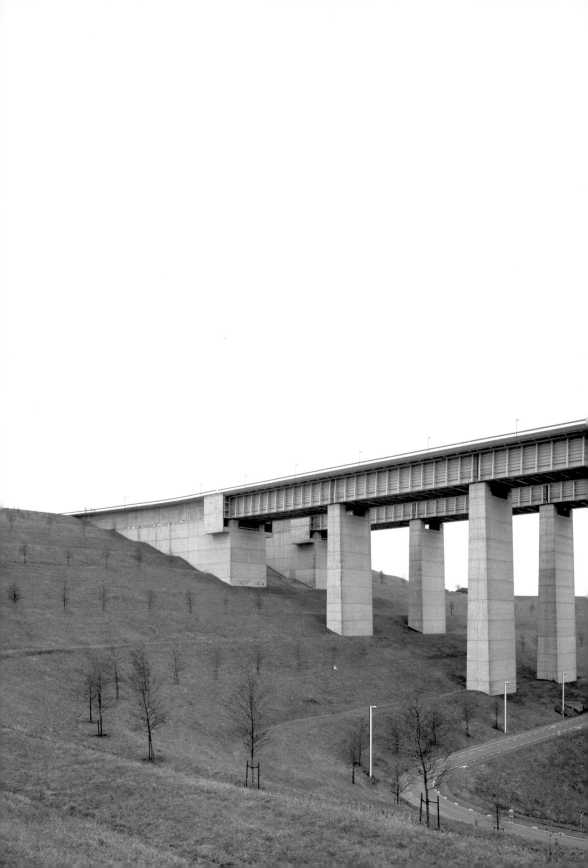

3. The Mortal Game of Fashion

If I were allowed to choose among the books to be published a hundred years after my death, do you know which ones I would pick in this library of the future? Oh well, it would not be a novel or a history book, my friend. I would simply take a fashion magazine to see how women dressed a century after my passing. And these flounces would teach me more about the future of humanity than all the philosophers, novelists, preachers and professors ever could.

ANATOLE FRANCE, preface to *The Psychology of Clothes* by Flugel. *Vogue Covers,* 1900-1970.

Nothing illustrates the notion of (perceptual, motive, semiotic or indicial) field effects better than fashion. In fashion, the idea of a code is merely a ruse. Everyone knows that the recommendations that could pass for rules (pleated shoes, skirt cut off at the knees, low waistline, more or less cleavage) are issued only after the fashion of the year already exists. These rules are a result. And besides, they are not made to be followed. They exist so that a vague discourse allows one to speak and to be attentive to a *line,* which is very precisely a curve, a particular modulation. It is a matter of the eyes, it is said, or the fingertips. Here, traits, volumes, colors, saturations, luminosities, and often luminescence mysteriously become compatible. This is not the case with texts, or even cinema or television. Here, there is an absolute need for the stability of photographic field effects. This is accomplished through the particular capability of the photograph to create *figures,* as we have defined them with respect to the photo-novel.

These considerations would undoubtedly have sufficed provided there only was an everyday and familiar fashion, namely that of *Marie-Claire* or *Elle.* But *Vogue* and *Donna* oblige us to offer more vertiginous propositions. Here, one can see that fashion is sometimes, and perhaps always, a harsh game of life and death revolving around the recapture of the fragile and unstable biological body into fixed analogical and digital signs, even on the verge of ceremonial ascendancy, of which the funerary apparatus would be fashion's latent ideal. Within the signed animal lurks the desire to be as "wise as images", or even as wise as *imagos,* that is to say, doubles of the dead. The Egyptians and Etruscans realized it full well. And this engenders new collusions with photography, which is also an authority on life and death in its exceptional capabilities of congealing, of giving shape to absent presence, of refusing to surrender. Here we encounter a tempered necrophilia as a form of moderate voyeurism, often shared by the connoisseurs of photography and the admirers of models. In this case, photographs do not have the function of doubling real clothes and bodies at all. It is rather the clothes and bodies that double the photographs. In this Venetian carnival, the mimes willingly mimic the negatives of the negative.

When *Vogue,* for a readership that understands the meaning of fashion, celebrated its seventieth birthday in 1970, the magazine contained no text, but only cover photographs. In it,

Nefertiti appeared as photographed by both Richard Avedon and Irving Penn. The intentions of high fashion have undoubtedly not changed since the days of the embalming practices in Egypt. The photograph, equally embalming, is merely allowed to develop and transmit these intentions. Japan's Fujii and Hiro demonstrate the same merciless bias to its inverse.

Image p.88: Sarah Van Marcke, *Looking for Rachel*.
Image p.91: Sarah Van Marcke, *Untitled*.

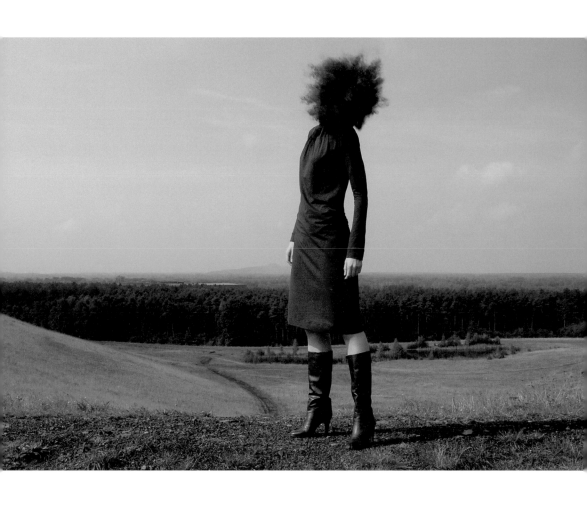

4. The Sentimental Eucharist

Rare photographs, resembling him as old family portraits resemble disappeared and anachronistic ancestors. Frozen, hieratic, beautiful. He did not like photographs.
CATHERINE CLÉMENT, *The Lives and Legends of Jacques Lacan.*

Sentiment is not synonymous with emotion. It does not contain violence or transience. It enjoys what lasts. But also what is kept in halftones. Somewhat absently present. A somewhat present absence. Occasionally with pangs and measured grief. Becoming attached to tiny curvatures and modulations. The photograph functions very efficiently within this behavior, at least in Europe. And it is with respect to the photograph that we have to measure, not without casuistry, all the subtleties of realism and anti-realism.

Let us have the courage to momentarily take up these necessary quibbles. There is something discomforting in a portrait photograph: photons have touched a film, and these photons have also touched a person. This means that a photograph is a contact surface for fragments of someone's *reality* (the inflection of a smile, ankle, or handshake) and also a contact surface for the materially *real* elements of someone (his or her aptitude for photonic reflection, the combinations between photons and the physiology of his or her body). But this photographic contact surface is mediate, carried out at a distance by mediating photons. It is also abstract, as these photons were selected according to focal lengths and especially according to a superficiality of field. This situation implies both an addition and a loss, as in one and the same touch sight is expanded but simultaneously reduced by the distance inherent in vision. This vision is augmented through touch, but reduced because of the inherent (obscene) proximity of touch. Simultaneously, this *visual* contact surface attempts to attain the real and the reality of the spectacle by laying hold of both outside of place and duration in an only physically determinable space-time, which, provided it does not compromise the real, exiles reality. Thus, the real and the reality of a person captured in the photograph were never in the mode of reality to us, and neither were they ever for this person. The photographed person is a *state of the world* irreducible to any other, just as any other photographed object. It specifically passes the moment the photograph is taken. The photo is a *one-time-never-again*, but we are unable to situate the spectacle in an actual duration, as opposed to recollections. In a word, the photograph does not show an apprehension, a perception or imagining *within* itself. As a major trigger of mental schemas, the photograph can only provoke waking dreams or reveries *on* itself, or, in other words, starting *from* its surface. To write "in memory of" underneath a photograph is not an explanatory caption, it is a complement or a compensation for what a photograph is not.

There are at least two major sentimental attitudes towards the photograph. The first, more Oedipal in nature, is well exemplified by Roland Barthes. Even if Borges did not explicitly characterize it as such, we would identify the second attitude as cosmological.

In the photograph, the oedipal practice tries to reinforce the aspects of personal presence. While accepting a certain distance in time *(that has been),* it strains to deny spatial abstraction. Thus,

the exterior cause of indices, i.e. the spectacle, is understood as a referent, a messenger sending (*or being*) a *message,* even a message without a code, divine speech, *fatum,* a divine nod of the head, *numen.* By predilection, this speech originated from lovers and loved ones, in particular from the parental couple, as the physical and moral origin, as justification and redemption of a viewer who regards himself as the sole and intimate interpreter of the *secret* (my reading of my mother's smile will die with me). As the photograph resists this treatment, through its abstractions and field effects, the sentimental bias retains details of a photograph – a detail, almost denotatively and connotatively defined that grants us the essence, the point, a pang, the *punctum.* Surely, Kafka was right when he said that the photograph is too superficial to endure the progressive exposures sentiment enjoys so much. Captured within this desire, the photograph calls for writing, *the pleasure of the text,* in the form of a tireless correspondence in Kafka's case or the *fragments of an amorous speech* with Barthes. In any event, everything is held together far away from the camera obscura and the black box in the almost insomniac *Camera Lucida.* One will have noted that a reading of details with an almost stellar intensity is particularly marked in male homosexuality, as manifested by the British poets of *The Male Muse,* the lively decoupages of Hockney's jointed photographs or Mapplethorpe's deposed unravelings.

But there is a non-oedipal usage of the photograph that we can call equally sentimental although it is *cosmological.* It is a case of tracing, in the multiple photo frame or the family album, the dissemination of resemblances and the miniscule, disparate and fleeting encounters of microscopic and gyrating traits configuring the photograph. And indeed, how, according to these luminous imprints, could this here, once having been that, have become this? *Is* a person, or does he *become* something? Or are there only singular moments, whose sequence is attached to a first and last name, and which we accordingly call the life of this person? The photographic interrogation of the species is equally radical. Which traits are yours, and which come from someone else? Which biological traits and which cultural traits do these twin sisters share, these parents and grandparents, these children, these monovular twins? But, again, isn't there a multitude of traits? Is not each one of them, as in Borges's *The Approach to Al-Mu'tasim,* an incidental and instantaneous encounter of imperceptible mental and physical spores, coming from the most distant and most scattered beings, along centuries and distant continents, and which only characterize a family because they are present more overtly at a given moment? Contemporary biology sometimes contends that life originated from cosmic clouds of particles capable of triggering vital events by virtue of particular local conditions. Does the photograph, through its sheer number, pattern, indices in overlap and the ability to transpose, not show that signification and meaning are always merely the fleeting precipitations from a cloud of infinitely small possibilities that are joined more or less fortunately at a certain time and place, and as such can never be pinned down? In the case of the multiple photo frame, this dissemination is even clearer than in that of the album.

The photograph is therefore the privileged instrument of the oedipal family, but it also partakes of, and more pertinently so considering its nature, the dissolution of the mommy-daddy-me

triangle. To the industrial migrant laborers, to all the nomads of our multiple journeys in body or mind, the photograph warrants a minimum of temporal and spatial references. But how? The mixture, on walls, of diverse relatives and showbiz stars creates an alternative family. So, it is less a matter of blood relations than mental relations. Our sociability without society fits well with this comet-like dissemination of physical and mental traits.

2. ARTISTIC BEHAVIORS

In almost all of our languages, the word art indicates two almost opposite notions which we will consider separately.

1. Everyday Art: Elucidation and Confirmation of Codes

Instead of favoring photography as art, the cultural policy of FNAC took into account its various incarnations as a mass phenomenon.
Carole Naggar, *The FNAC Collection.*

Man as the signed animal is truly constituted by images and sounds, some of which are natural although many are conventional and therefore function as signs. Thus, at all times and everywhere, man is inclined to produce images and texts whose codes are exceptionally *visible and consistent* so that he can configure himself and the group to which he belongs. These image-signs and discourses, whose codes are obvious and well-coordinated, are used eloquently by man, just as the objects and bodies he finds. He feels pleasure whenever he encounters them. This might be called everyday art. A nice drawing, a melodious song, a nicely written or spoken text, as well as clothes, utensils, a comfortable home, a committed or conventional political image – these can all be sources of joy.

The photograph evidently has an output rich enough to fulfill these criteria. The indicial character is carried over onto the imprint, and these indices are strongly indexed. These indexed indices refer to signs or object-signs, sometimes to stimuli-signs, and very often to figures in the classical sense of the term. And this indexation answers to visible and relatively coherent codes. Denotations, connotations, and perceptual field effects are immediately decipherable and contain almost no false cues. Up until the nineteen fifties, this type of photography undoubtedly organized its field effects more formally, or rather, more forms and depths were distinguished according to the ideal of Western perspective and production. By contrast, nowadays the overlaps of forms and depths are sometimes welcomed, as evinced by David Hamilton's popularity. But this still concerns mostly directly *recognizable* codes to members of a broad group at a given moment.

It is possible that the photograph, owing to its isomorphism and synchrony, as well as its temporal, spatial and physical superficiality, is particularly apt at fulfilling this social function. The postcard and the poster have become typical examples of everyday art in almost every field. Today they relay what were once, in the era of painting, the *images of Epinal*. In his booklet *The Photograph*, French photographer Edward Boubat presents a clever and delightful collection of rules governing good photographs of this type. The cover of the book shows the democratic tenets they often carry.

The photo novel is an extreme case. It not only applies immediately recognizable and very strict codes to the images, but also to the words and to the sequencing of events, thus effecting a generalized rigidity and clarity. By virtue of the photograph as imprint, it can pretend to create more real situations than those evoked by a simple text. However, it simultaneously disconnects these situations from the complexities and the unpredictability of real life. This is attained through the absolute legibility of indexes, through the grouping of successive moments on the same page (thus demonstrating the code governing their sequencing), and through the ostensible disconnection of the characters whose words, gestures and facial expressions are not in sync (in particular, their mouths remain immobile). One could even say that the photo novel tries to create *non-situational situations,* where the reader feels close to everyday life while moving within a prudently demarcated fantasy, enabling a projection without the risks inherent to passionate identification or empathy. The legibility of codes is so strong that the photo novel is no longer an object for sociology – it is almost ready-made sociology in itself.

2. Extreme Art

The act we will dub extreme art is not the perfecting of everyday art as a way of exceeding it. To a large extent, extreme art follows a strictly inverse path.

a) Radicality

Instead of providing correct forms and harmonious compositions, that is to say, instead of clarifying and accounting for societal codes, extreme art radically questions things. At the same time as signs, and also on their level, extreme art envisages how they structure and de-structure themselves, keeping in mind that, without exception, they can only locally and temporarily capture the chaos, pre-structures, and quasi-relations – signs can never fully seize the latter. Thus, not only is extreme art animated by the drives of life and death, it also explores the entropy and negentropy of all systems, as well as sense and the absurd, thereby unveiling the gap and the anti-scene (beside-the-scenes, before-the-scenes and the after-the-scenes) of every language, figure and construction. This is what Rabelais, Beethoven, and the Dogon and Olmec sculptors put to practice. This surely also applies to the intransigence one can find in sexuality, fundamental science, philosophy, sports records and mysticism. Extreme art is the version where man presents himself with both a mental capture of what is at the "heart" of things, as in fundamental science and philosophy, as well as a sensorial capture, as in sexuality, mysticism and sports.

The photograph responds remarkably well to this. One need only recall what we have discovered about its texture and structure. Like all imprints, its zones are steeped in the anti-scene of pre-semiotic quasi-relations. Its indices, which are never defined as regards to their border, number, and exact range, reinforce the capture of fluctuations that shake systematics. Its spatial isomorphism and the synchrony of its registration immediately instill a terrible impartiality which goes before, after, and outside of all duration and any familiar timeframe. While dissolving reality, its absence stands in for the real, and therefore, in a certain sense at least, it is present in the upheaval of being and non-being that makes every ontology tremble. It frees itself from structural links with the infinitely large and the infinitesimal, hurling us back to the origin. It forcefully inscribes the universe as a succession of irreversible states – the *never-again-nowhere* of any event. It brings out little of the situational of any situation. And the human body appears continuously at the bottom of authorial intentions, giving away an unconscious, a "that", which is no longer merely psychical but also cosmo-physical.

The photograph therefore has all it takes to satisfy those who wish to pursue the radicalizing impetus of extreme art. This does not entail miming the effects obtained in other age-old practices, such as painting for instance, whose effects are normally those of everyday art. Extreme art is produced when photography is faithful to its own texture and structure.

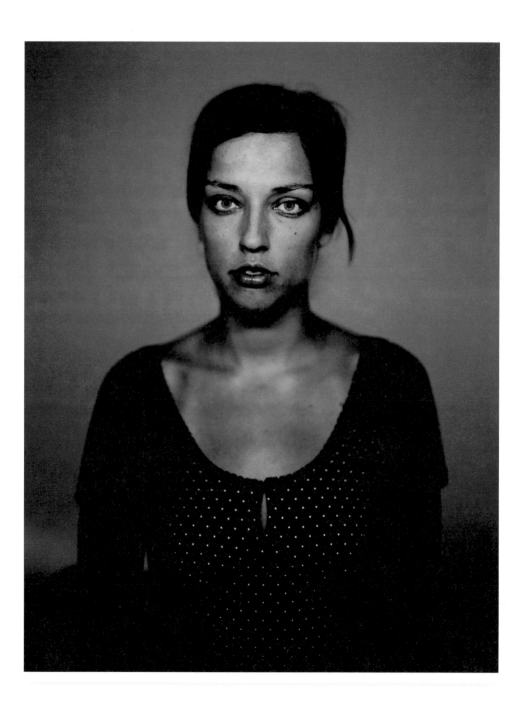

However, extreme art does not employ the world as its setting in an undifferentiated manner. Its products are always marked by a society and, within this society, by biological and semiotic individualities. It might stem from what the group or the individual wants to express deliberately, as was the case with romanticism and expressionism. But originality persists even when it is not pursued for its own sake. The radicality of the products of extreme art is always seized from a certain angle, through a singular revelation or construction, causing Mozart, Beethoven, a Dogon or a Polynesian to produce equally radical results that make each of them directly recognizable. Few are marked by their denotations or connotations, which are broadly shared anyhow; they are mostly marked by their perceptual field effects. These are so specific that one could designate them by the term pictorial *subject* for painters, the architectural *subject* for sculptors, the architectural *subject* for architects, and the textual *subject* for writers. These *subjects* designate the specific *rates* of aperture-closure, density-porosity, continuity-discontinuity, concentration-diffusion, and so on, which bring forth sounds and rhythms in music; traits, touches, colors, volumes, and materials in architecture, painting and sculpture; sounds, rhythms, and curvatures between logical and fantasmatic series when dealing with literature.

Once again, the photograph can here join the other arts. Let us name a few particularly insightful cases. Robert Capa is identifiable through delicately wrapped lighting, no matter whether it concerns a mountain, trousers, or bloodstains on the ground. We recognize Cartier-Bresson through salient volumes, which he captured in the photographs of prostitutes of Mexico City and North African children in a courtyard. We recognize William Eugene Smith through tapered angulations that invigorate the "coloration" of black and white contrasts, which culminated in *The Spinner*, and which he found in rural scenes, the posture of a doctor or of family members at a wake in a Spanish village. We can recognize Edward Weston through a texturology in which an impartial focus intersects with things and light, arrangements and degeneracies conveying a certain eternity. Dorothea Lange produces an articulation she desired to be audible, phonetic, in the back of a shirt or the branch of a tree. Walker Evans gives us frontality, planarity and magnified quadrangularity. William Klein: the panic of the turbulence of urban events. Avedon: the physiology and geology of epidemics. Irving Penn recognizes himself in the tension between luminous pomposity and mortal cuts. André Kertész: blinding structures. Robert Mapplethorpe: edge to edge filled with large areas of imponderable dimension, where all forms, left behind rather than immobile, well up, in a slow instantaneity, to forge a connection between the void and the fragment.

However, it has to be stressed that *photographic subjects* do not posses the same resolve as textual, musical, pictorial, and architectural subjects. Vivaldi is almost immediately recognizable from his first to his last work, practically measure by measure. Painters, architects, writers and musicians evince great constancy, even if it is that of inconstancy, as with Picasso for instance. Their musical, textual, pictorial, and architectural "subjects" vary little whatever the denotations and connotations they revert to. Furthermore, it is the artist who chooses the denotative and connotative

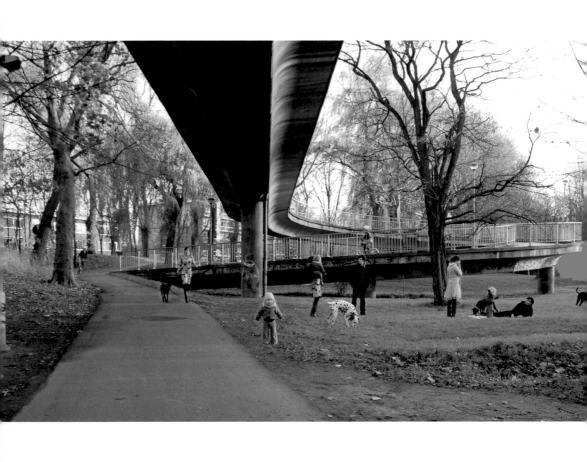

themes that might, according to his intuition, harbor perceptual field effects. The photograph is different.

It is the aforementioned Avedon who made fashion photos for *Vogue* of celebrities he invited to pose to exhaustion, photos bespeaking the death throes of his father: the three series complement one another, and they even partake of the same physiological and semiological interest for the life of death. But undoubtedly this link is more apparent when we associate Mozart's operas with his chamber music. When looking at a painting, we involuntarily exclaim, due to the determinacy of the pictorial subject: here we have a Rubens, this is a Hockney. Before a photograph, one can hardly say: This is a Capa, an Avedon, a Cartier-Bresson, or a Walker Evans.

One could regret this situation, and see it as a weakness. Alternatively, one could sense something original here, and be attentive to it. If human intervention is less imperious to photography than the other arts, it is because the universe-world barges in more than anywhere else. In addition, the transmutability of the photograph instantly allows it to evade its author, which cannot be said of most other productions.

We have yet to discuss photographic *style* in addition to its subject. We have not addressed style because it originally referred to the quill, and because the quill, whether with respect to text or drawings, refers to the graph, and therefore to the field of signs, which does not pertain to photography. The word 'subject' in *photographic subject,* far from being ideal, does not have this disadvantage, at least if one marks it off clearly from the *theme* or the *scenic subject* of a photograph. Besides, "subject" has the virtue of clearly indicating that photographic field effects are not simple forms (embellishments of a contents, in the classical sense), but constitute a perspective, a vision, an overall capture, a fundamental phantasm and a different kind of denotation, which, partly existential, is often the true "contents" of extreme art but also of publicity. Moreover, the term "subject" does not sever the photograph's field effects from the photographer's, or, in other words, it respects the link between the photograph's texture and structure and that of the decision-maker's brain. Even if a photograph *by* Cartier-Bresson is not really *a* Cartier-Bresson (as one could say of his paintings), it still goes out *from* Cartier-Bresson. What we have before our eyes are not only imprints and indices steeped in their field effects, but also mental schemas forged by the same field effects. The activity of looking at a photograph struck us because of its extremely apposite activation of the indices-mental schemas couple (in the plural and in overlap). The act of photographing astonishes because of the same characteristics. With the same effacement of long-standing *subjectivity,* as the centre of reality and the Cosmos-Mundus, to the benefit of a *subjectality* transfixed by the real, as a universal state amongst many other universal states.

c) The Only Slightly Reflexive Indicialogy and the Impossible Self-Portrait

Finally, it is rather unlikely that someone pursuing extreme art will not end up, at a certain moment, engaging in a particular form of radicality and singularity, i.e. the interrogation of the nature of the medium itself. A reflexive attitude asserted itself in all the arts from 1950 onwards,

giving rise to paintings about paintings, sculptures on sculpture, literature about literature, music on music, and cinema on cinema.

Is there such a thing as *photography on photography* as well? One can find examples pointing in this direction. Dibbets brought out the importance of skylines in the shot. Moholy-Nagy thematized the meshing and weaves of the photo's shades, as Zielke itemized the transparencies and leafage of light. Ernst Haas practically made a systematics of the originary pairing information-noise in the fusions of color photographs. Friedlander carried out the most thorough exploration of the implication of the photographer in what is photographed. One could say that the series of captioned photographs by Duane Michals and Nakagawa are not only narratives-figures, like photo novels, but reflections on the figural (not figurative) aptitude of the photograph, by virtue of the gap between the captions and the ambiguity of the shots. Finally, Douglas Crimp shows that as early as 1895, Degas, conspiring with Mallarmé, had produced a veritable semiotics or an actual indicialogy of photography.

Even so, one could maintain that the photograph is less driven to this type of self-referentiality than other artistic endeavors. Paradoxically, the photographs of uttermost reflexive significance have often attained this only by accident. Everyone knows Robert Capa's famous series of the landing in Normandy. The film was ruined in the London studios. In the end, eight negatives survived the accident, which only serves to intensify one of their fundamental aspects: photos are problematic imprints. The result of this mishap activates a staggering semiotic and indiciological complex concerning the nature of present or absent appearance, manifestation, and events. But the fascination, so well-suited to the nature of photography, arises not from premeditated intentions but from an exterior accident.

The self-portrait is a good test for the highly irregular reflexive possibilities of signs and indices. The classical painter, working with semiotic traits, excels in this genre and confirms his 'Me', his microcosm. Here, the photographer, trapper of contingently indexed indicial imprints, fails. 'Me' is a matter of the mirror, as Narcissus believed. The photograph is not a mirror. In a photograph, the "I" is captured from the back and in delayed-action (Denis Roche), in its black shadow (Tress), as an anticipated corpse (Schwarzkogler), as a reflection among reflections (Friedlander). However, in the latter case the 'I' discovers its positive status: to be a state of the universe among other states.

Image p.98: Britt Guns, *Britt*.
Image p.100: Britt Guns, *Loes, Maarten, Lola and me*.

3. SCIENTIFIC, DOCUMENTARY AND TESTIMONIAL BEHAVIORS

Brassai had normal sight. But he had a cosmological eye.

HENRY MILLER

It is said that the intention of the first photographers was pictorial. It is also claimed that the intent was scientific. Both affirmations overlap. For two thousand five hundred years, Western painting and science have been reflecting one another in their search for reality, a reality assumed to be composed of substances, which in their turn would harbor an essence, that is to say, a type, a nature, as well as an individuality. Science was more abstract, painting more sensory. In both cases however, it was a question of capturing reality. In its early stages, photography set out to complete this aim. In 1839, Daguerre captured the spirit of the Tuileries. A photograph of the Moon is dated 1853. In 1855, Albert Sands Southworth attempted to totalize all the angles of a female face in an oval medallion by depicting a frontal shot surrounded by eight profiles. Nadar tries to penetrate into the radiant characters of Daumier, Delacroix and Baudelaire. Around 1880, Eadweard Muybridge, through shutters working at 720^{th} of a second, records short phases that, once put together, would explain the complex behavior of nerve-attacks or the gallop of a horse, at least to the photographer's associating eyes. Georges Demeny does the same for speech. America tried to get an overview, as the term "survey" indicates so well, of its landscapes and population. The rest is history.

In truth, the photographic practice precisely demonstrated that there was no substance, no essence, no type, no stable character, no radiant individuality, and no atoms of behavior. It even demonstrated that there is no such thing as a true situation, understood as a collection of events reducible to an interconnected overall meaning. Photographs of criminals were put side by side with those of law-abiding people, and on asking to distinguish the one from the other, interviewees would confuse them. For the photograph there are neither born criminals nor saints, neither lunatics, nor sages. More generally speaking, there is no true being, no authenticity. There is only the dissemination of actions, signs and indices. No other medium than photography better illustrates the thesis that there are no grand systems, whose remainder would only constitute subsystems. By contrast, the photo reveals that, for all orders, the small local and transitional open systems somehow always make themselves compatible and only remain so for a while in function of these compatibilities. In biological terms, the photograph is populationist. It is not essentialist, not generic, not specific, not biographical, and certainly not hagiographic. Furthermore, the photo clearly reveals how all views actually encapsulate several 'shots', immediately involving scaling, angle, perspective, sensitometrics, exposure time, and superficiality of field. In other words, it indicates the reciprocal involvement of what is photographed and the object doing the photographing, thus disclaiming pure objectivization, even as a vague or ideal concept.

The photograph imposes the idea of a *science* that is not a *knowledge*. It is precisely a practice of non-knowledge, simultaneously precarious, problematic, and rigorous, and continuously colliding – from angle to angle – not with a single and reassuring reality, but with the disparate and uncomfortable real. Whether capturing coiling nebulae, a fallen soldier, a cancer devouring a face, the smile of a child, or a handshake, the photograph does not show a Cosmos-Mundus, but the world as a jumble of quasi-relations in search of new relations, which in their turn are producers of new noise, and new relations.

This explains why, even when tackling themes that are strongly articulated by reality such as war, famine, love, or holidays – in brief, life – one often uncovers, underneath all these behaviors, a specific attitude that is less realistic than real, and which could be called *testimonial behavior*. A witness is neither a propagandist nor an informer, but somebody who says, following Jean de l'Epître: this is what I saw, this is what I touched. I pass it on to you with the greatest care for the real, and with the least care for reality. After that, it is up to you to see. As an imprint, albeit abstracted, the photograph possesses this impartiality, and when it is indexed, the photograph can be a given-to-view (*le voici*). We stressed the fact that the photograph is already in itself a given-to-view, and that it can profoundly affect us as pure automatic recording, without index, without given-to-view, and therefore without any human behavior, or at most very oblique interference (putting down a camera somewhere automatically taking shots). The simple given-to-view of the photo as eyewitness account is then the minimal index, and therefore the minimal degree of the intentional photograph. It can be said that this is the behavior that most respects the photographic nature of the photograph.

This testimonial side is practiced in the reportage, which is perhaps why many people spontaneously identify reporters as the photographers par excellence: Walker Evans, Dorothea Lange, Capa, Plossu, and so on. Is it because their work is so raw, or because it is so richly psychological, sociological, political, or religious? Or precisely because they contain a given-to-view we ultimately cannot say anything about, and which puts us directly below or beyond psychology, sociology, and politics, in a penetration of reality by the real that can only be described by Miller's adjective: *cosmological.* As such, the frame-index is generally very discreet; it has the spontaneity of a simple frame-border. The testimonial photograph differs greatly from the photograph that takes a stand, the committed photograph.

The difference solely concerns the reporter. In photographing a cypress root or a dune, and bodies or houses as cypresses or dunes, Weston comments on the *impartiality* of the camera eye, in that it does not transmit any message. The nude photo of O'Keeffe by Stieglitz is of the same order. Here we see, from over the breasts to above the knees, luminous imprints of the vegetative part of the human body, the place of organic exchange, without any of its active parts (the region reserved for the right hand, paralleling the absence of the rest, is passive). Here we see the three sites and the three periods of generic exchange: the past of the navel, the future of the breasts, and the present of sex. We view tips, hollows, bushiness. Days, shadows, night. The view

as touch. Though subtracted from reality, it contains a high degree of the real. Thus, nothing is constructed, there is no thinking, no discerning, no imagined, but there is a physique, a chemistry, a truly exterior physiology, i.e. that of weight and the development of breasts on a torso, that of the torso on the columns of the thighs, that of pubic vegetation. Surely, Stieglitz internalized the Venus de Milo and the techniques of chiaroscuro. However, no painter, not even Titian, could attain this derivation of a body; not a body according to our eyes, but a body attuned to itself. The moment the Young Fate utters the words "*I saw myself watching myself, with every look gilding my deepest forests*", (cf. Valéry, "The Young Fate"), all is captured in a thought. In a photograph, there is the silence and the fascination for the pure and cosmological given-to-view. Here are, given to view, at least the effects of photons having touched this or that.

Overall, we perhaps formulated the issue inadequately. We asked ourselves which behaviors could benefit from photography. Our answers focused on the pragmatic behaviors of pornography, publicity, fashion, and sentimentalism; on artistic, everyday or extreme behaviors; and on scientific or testimonial behaviors. However, our attempt was to embed the photograph into the worlds anterior to it, into behaviors already defined prior to photography. As such, the photo introduces a truly novel behavior, i.e. *photographic behavior*, which simultaneously challenges – or thoroughly redefines – art, pragmatism, science, and testimony in their traditional sense. In all these long-standing behaviors, surely its testimonial silence is most common. But what noise human silence still makes compared to an intersidereal phototonic silence!

As photography is closer to the universe than the Cosmos-Mundus, its pedagogy had to be especially *negative*. No, no, it is still too much of this or that, as Brodovitch would repeatedly say without ever accommodating himself to a 'yes', to an affirmative. There is something Zen-like here, or something resembling the old negative theology, because we can agree that the universe is precisely that which is never either this or that in the world, or even either this world or that world. Any photograph that makes us think about its nature is undoubtedly strictly indefinable, as well as the behaviors producing and receiving it.

NEW THEORETICAL PERSPECTIVES

Many years have passed since this work was first published by the Brussels Centre for Fine Arts in November of 1981. It was deemed unnecessary to alter the final version published in the spring 1983 issue of the *Cahiers de la Photographie*, with the exception of two or three mistakes.

However, certain clarifications were meanwhile brought in. The text strongly insists on the fact that, unlike any other type of imagery, only photography (and consequently also photoengraving), is able to capture the "quantic" character of the Universe by virtue of its granularity, that is to say its physical composition consisting of grains. Physicists – and Erwin Schrödinger in particular – have long since pointed out that without the quantic structure of energy (the irreducibility of *h,* the quantum of energy), our Universe would be absolutely continuous, and therefore unable to instigate events or give rise to individuals. Thus, the photograph is already philosophical by virtue of its granularity. However, when the quantic character of the photoelectric effect intervening in the *formation* of its negative was fully thought out (it is the photoelectric effect as interpreted by Einstein that helped to give Quantum Theory its definitive shape), it left the quantification of the *development* of the negative foolishly obscure. But things have changed since the discovery of the intervening "quantic size effect", as the authors explain in their article "La Photographie Révélée" of the 1990 January issue of *La Recherche.* The appearance of the word "quantic" in this text confirms this original and cosmological aspect of the photographic process, even though the authors do not employ it in the radical sense as with photoelectric effects.

But the philosophy of photography is further illuminated by lights coming from further away. Firstly, light is shed by what is today often called an intelligible ontology. Secondly, a better understanding of our primate visual system offers additional clues as well as a more anthropogenic model of man. A brief exploration of these three perspectives will give new resonance to the connections between Indexes and Indices, as well as to the differentiation between Reality and the Real, and between the World and the Universe – themes that form the backbone of this book.

1. Photography and Intelligible Ontology

Homo sapiens sapiens as primate, and even already as mammal, has always perceived that his environment contains folds, ridges, crests, holes and so on. And whoever tries not only to identify persons and objects, but also to draw out and pay close attention to the germination of forms in a photograph must follow these creases, edges and fault lines.

What has changed over the last few years is that catastrophes and alternations of form brought about a certain mathematization with the introduction of differential Topology and differential Analysis. As such, what had always appeared as an ensemble of *de facto* practical characteristics has

refashioned itself in *de jure* systems. The realization grew that the fold, the cusp, the swallowtail, the butterfly, the hyperbolic, elliptic and parabolic umbilic (the order is meaningful) account for the seven elementary catastrophes responsible for many (the ensemble of?) macroscopic formations and transformations in the Universe. The first edition of René Thom's *Structural Stability and Morphogenesis* (SSM1) was published in 1972 by Benjamin, Massachusetts, while a second expanded edition (SSM2) in French was published by Interédition in 1977. His *Semiophysics: A Sketch* was originally published in 1988 as *Esquisse d'une Sémiophysique* (ES), also by Interédition.

In this new frame, distant or near surroundings (as well as photonic imprints of the surroundings) no longer simply offer an aleatory table of samplable objects one knows little about, but a formal *field* occupied by *morphic attractors* whose combination determines the pool of morphic attractions that compatibilize divergent forces, thus facilitating *gradients of morphic potential* with differing rates of smoothness, abruptness, simplicity or complexity. As transformations do not cross from one form into another in a continuous and equal fashion but in a catastrophic manner through morphic *leaps* – effecting *stable*, *unstable* and *meta-stable* states – the Universe is able to assumes its "quantic" nature not only through the behavior of its elementary particles or of its "small" size effects (photographic development), but also – and this clearly concerns a much larger scope – through the forms of its mountains and living organs, from one species to another, and perhaps especially from one epigenetic stage to another.

As such, some SENSE is conferred on the sequence flower-bud-fruit, on the successive unfoldings of our embryos, the umbilic of our mouths, stomachs, anuses, matrices and "peaks" (the elliptic umbilic) of seminal injection. On the basis of the "singularity" $f(x) = x^4$ and the "universal unfolding" $F(x,u,v) = x^4 + ux^2 + vx$, the creases of a Coco Chanel skirt flirt with the planetary syncline and anticline faults, as laid down in the "Riemann-Hugoniot Catastrophe". One can now even start to understand something of the nest-building and nursing of birds, which the behaviorist theory of reinforced efficient sequences had rendered quite mysterious. Jorge Luis Borges has taught us so well that, even for the most perverted imagination, monsters are limited, very limited, in number. The pioneer in this field was D'Arcy Wentworth Thompson whose *On Growth and Form*, first published in 1917 and since then subsequently revised and extended, showed that, for animal forms, the Universe operates morphically according to "chreodes", or pathways of probability, which are relatively limited in number. This is the concern of that transmutational multi-frame that is called the comic, which is the constant verification of this evidence. Indeed, we attempted to illustrate this point in *La Bande dessinée, une cosmogonie dure* (Cerisy Symposium, Futuropolis, 1989).

In this respect, the photograph occupies quite a remarkable place. While the signs of a painting are inevitably prefigured even when they distort or seek to be pre-formed like with Renaissance marbling, a photograph, as an indexable indicial imprint, offers all its forms together with its non-forms, on the brink of catastrophe. The photo not only gives evidence of the fold, but also of folding.

This is even more so as, technically speaking, the photograph is in itself a catastrophe, and conspicuously so, which René Thom does not fail to stress while seemingly speaking of something entirely different, i.e. the notion of "mean field":

> "Is not photography a *controlled chemical catastrophe* the germ set of which is the set of points of impact of the photons whose existence is to be demonstrated?" (SSM1: 113).

Thom adds that "the same is true of the bubble chamber or scintillation counter in the detection of elementary particles" (Ibidem), explaining that the germ set is the "set of points where the new phase appears" (SSM1: 106). Furthermore, when in one of his paragraphs René Thom ventures into art, he of course hints at paintings, poems, musical phrases, and dance steps, but he above all makes us think of the phototonic imprints of the photograph:

> "The work of art acts like the germ of a virtual catastrophe in the mind of the beholder. By means of the disorder, the excitation, produced in the sensory field by looking at the work, some very complicated chreodes (of too great a complexity to resist to the perturbation of the normal thought metabolism) can be realized and persist for a moment. But we are generally unable to formalize, or even to formulate, what these chreodes are whose structure cannot be bent into words without being destroyed" (SSM1: 316).

"Complexity" here means "systematically excited" and refers to an execution which seems "directed by some organizing center of large codimension" (Ibidem). Stéphane Mallarmé must have turned in his grave upon hearing this mathematized version of his equally rigorous definition of artistic production: "Vertigo! / How space quivers / Like an enormous kiss / That wild to be born for no one can neither / Burst out or be soothed like this". Thus, for every photograph, the cerebrum of the photographer only constitutes a minimal part of its "organizing center", which is largely comprised of the chreodes of an ambient Universe. This is even better news for those in search of an "intelligible ontology".

Besides, the refreshing view instigated by differential Topology and Analysis complements the present-day revival of a general Topology. For those who always believed that the existential FIELD activated through art, literature, publicity, love, religious fervor, or the discreet ecstatic happiness of sitting in an armchair by a window at a certain hour of the day (ah! Rousseau!) was not the work of denotations, and connotations, nor of the signifier or the signified, nor of reference and code, nor of expression and contents, nor of circular permutation, nor of barred signs, nor of floating signifiers, nor of a "Punctum" turning the viewer or listener into some sort of semiotic Saint Sebastian, but who instead believed it was due to original RATES of opening/closure, near/

distant, globalization/enclosure, contiguous/non-contiguous, continuous/non-continuous, compact/diffuse, route/non-route, adherent/non-adherent, and so on, through which the Universe resounded sovereignly and fragilely – what enormous vindication to all of them to hear that the topologist – this fundamental mathematician – cannot stop talking either about vicinity, adjoining points, open/closed, continuous/discontinuous, contiguous/uncontiguous, encompassing, encompassed, adherence, routes, and nodes!

What a happy encounter between mathematics, physics, embryology (Conrad Hal Waddington's *Organizers and Genes* of 1940), and even phenomenology, which Lévi-Strauss considered the philosophy for starry-eyed young girls. Edgar Allan Poe's *The Raven* is therefore not just a matter of tonal equivalences, as Jakobson contended. Instead, it concerns the RATE of near/distant sounds (and so many other aspects). In brief, we are dealing with a mode of existence! This also holds for photographs.

Nonetheless, one must keep in mind that intelligible ontology is far from completion. As Waddington (SSM2: xiv) briefly noted, in order to truly understand the formations and transformations of minerals and living beings, we still need to undertake the considerable task of reconciling the *macroscopic* morphological views of differential topology with the (steric and allosteric) *microscopic* morphological views of chemistry. More precisely, we still need to know how to pass from a space with a very large number of dimensions, such as the space that parameterizes the biochemical states of a cell, to the merely four-dimensional space-time of embryology. This enduring perplexity mitigates our joy.

2. Photography and Primate Vision

1982 saw the publication of David Marr's *Vision: A Computational Investigation into the Human Representation and Processing of Visual Information* (Freeman). After his battle with leukemia, the author died two years prior to the publication of his book. Since 1973, Marr had benefited from the exceptional research facilities and discussions at MIT's Artificial Intelligence Laboratory. His work, although never finished, is Mozartian, as if it were written as a *Requiem* on his own death at thirty-five, at the same age as the composer. "This book is meant to be enjoyed" is the opening sentence of this masterpiece of suppleness, which the publisher further emphasized by opting for an open format and ductile paper. Bless the country where they erect tombs like these for you!

David Marr inaugurated the computational theory of vision. This means that he is not concerned with the location of visual operations within different areas or relays, which is studied by physiologists, but with the *a priori* computations (filters, zero crossings, etc.) and with their sequence along differing levels. This series in fact enables our nervous system to elaborate a 2.5 dimensional "viewer centered" object from our two-dimensional retina. In a last step, this "viewer centered" object becomes three-dimensional, or "object centered". In the fifth and closing chapter of *Vision*, Marr asks himself how, once it is constituted, this object can be identified, stocked and retrieved by memory. He answers that the object distinguishes itself through the number and proportions of segments it takes up in an ideal cylinder of reference. One of the most distinguished researchers focusing on the cerebral

cortex of the cat and the primate would conclude shortly after: "Meeting these challenges is the immense task awaiting visual neurophysiologists in the coming decade" (Guy Orban, *Neuronal Operation in the Visual Cortex,* Springer Verlag, 1984, p. 341). With respect to our discussion, it is particularly relevant to note how neural computations are capable of deciphering indices by indexing them in various ways. This confirms the cleavage function of the retina (and the cerebellum or "little brain", which, moreover, is an evagination of the cortex), and the countless feedbacks between optic relays *(The Human Neuronal System,* Sydney, 1990, chapter 28).

The photograph, as a contingently indexed indicial imprint, is intimately affected by these problems that address the indexation of an indiciality. The photo is so well provided for in this respect that photographers took as a photographic subject the exploitation of the chemical catastrophes that are produced from the moment of the shot and the development of the negative, right up to the positive and the photogravure. The viewer is therefore able to wander through the preliminary stages of visual construction, in 2.5 dimensions (Mario Giacomelli), or through the progressive nomination of the object (Ralph Gibson).

In addition, the reference to physiology clarifies another curious point, as looking at a photograph can strike us foremost as a bizarre performance. Indeed, on the one hand, here we have a peculiarly immobile and inert object due to its Cyclopean nature and its registrational isomorphism, and which is furthermore often simply rendered in black and white. On the other hand, this object is captured by a primate visual apparatus whose structure is the result of millions of years of natural selection motivated by the imperative to differentiate food, enemies and partners in high tropical and multi-colored forest, where it was beneficial to have at least three types of visual receptors, namely two working in low frequency, and one in high frequency, and where a simultaneously lateral and centering eyesight was equally efficient in the continuous delousing and grooming and the recognition of faces and ocular expressions of congenerics, who precisely displayed the peculiarity of comparatively differentiated faces. Therefore, is looking at a photograph, especially a black and white one, not a vertiginous performance of abstraction, construction and coding?

We should perhaps not overstate the point. In effect, over the last two decades it has been confirmed that, in primates' vision (and in that of others as well), signals of form, color and direction of movement are transmitted from relay to relay and from area to area according to predominantly coaxial and distinct – yet interconnected – neural pathways. One can gain some understanding on this topic after reading the chapters on vision (i.e. 28 to 31) in *Principles of Neural Science* (Elsevier, third edition, 1991), or *Eye, Brain and Vision* (Scientific American Library, 1988) by David Hubel, who is one of the pioneers in the field, or more succinctly but no less significantly in the article *La construction des images par le cerveau (La Recherche* of June 1990) written by Sémir Zeki, another pioneer. According to the hallowed expression, there is no "grandmother cell" of the blue-teapot-pouring-tea, or even simply of the blue teapot.

In other words, even in our perceptual zones, which are however the most continuous – therefore the most "idealistic", as Jean Nogué called it in his useful *Esquisse système des qualités sensibles* – there is unity of the perceptible in terms of operational unity. More precisely, there is only unity of the

perceptible within the complete cycle *perception* → *motoricity* → *perception*, etc., where the dominant arrow always points to the outside (towards the prey, the partner, the enemy), therefore in global precipitation (*prae-caput*, or head-first) of the mammalian organism towards its environment, which entails that it perceives literally *onto* its environment, and *within* the segmentalization it brings about there. As with all other objects, a photograph is "viewed" *across* this independence of receptors but *within* this objectivizing circuit and milieu, which means that the viewer needs no abstraction, and often even no real interpretation to form unities. Moreover, the cerebrum of superior mammals is extremely suited to pluri-centration, that is to say, to changes of centers of attention (while observing a dog on the sidewalk, for instance). Furthermore, at least with humans, visual pluri-centration does not even necessarily presuppose movement of the eyes.

As such, the physiology of vision clarifies the perceptual functioning of photography, which in return clarifies our vision. The primitive would perhaps not succeed in reading a photograph after a first attempt, as he must recognize its character of non-reversed imprint. But, after this initial hurdle, anything should be possible.

3. Photographs and Anthropogenesis

In general, the human sciences are in such decline because they seldom consider the anthropogenesis, i.e. the order in which human accomplishments are set up in space, and because no attention is paid to the establishment and reestablishment of every individual's epigenesis and the instances when man's vigilance rouses him from sleep, torpor, distraction and loose focus, which are his most constant, not to say primary states (negentropy is always but a local and transitional lifting of the general entropization). By adopting the flattering credo that humankind was born with language, anthropology ignores the perceptual and motoric field effects of images, as well as the pre-linguistic indicial field. Thus, anthropology distorts things from the very beginning.

Examined rigorously, the photograph asks us to put things back into their right place, or rather, in their right sequence. Unfortunately, we lack sufficient space to develop a full anthropogenesis here. However, we can outline certain aspects so as to invite the reader to associate these with any photograph so he can gain a better understanding.

This is therefore a condensed anthropogenesis. *Sapiens sapiens* is the primate who progressively distributes his environment in increasingly stable *segments* by virtue of his simultaneously focused and broad primatial vision together with his upright posture and two flat hands with opposable thumbs, of course combined with a correlative neocortical development. Furthermore, with the transversalizing comparisons favored by flat hands, thus rendering them indexational, topologizing, and geometricalizing, certain environmental segments are captured as interchangeable, as being different or elsewhere than they actually are. In other words, they have been *possibilized.* The technical domain therefore strictly consists in the *panoply* of segments of an environment where the *animal instrument* (the frontal extension of the body) turns into a *human tool or instrument* (transversalized and possibilized). These segments function at the same time as *indices* of one another: transversalized and possibilized, the

nail is the indicial of the hammer, and vice versa. In addition, a well-understood indiciality is already a first imagery or potential diagrammatization, or, put differently, a first set of distant reciprocal projections between segments. Moreover, in the context of indicial, transversalizing (diagrammatical) and possibilizing technics, modular respiration, even dentition and a high pharynx (compatible with upright posture), call forth *sustained sounds* of music, and (after, during, before, or in a circular causality of these three) the *discreet sounds* of language, the latter having selected the development of the digitalizing centers of our left hemisphere (the *arcuate fasciculus* connecting the Broca Area with the Wernicke Area). In this manner, the analogical and digitizing representations of techniques were able to organize the fully analogical signs of painting, the simultaneously fully analogical and digital signs of the words of a language, as well as the "figures" in writings. As for indexes, once they were transversalized, they gave rise to mathematics and the general coordination of indexations (direction, consecution, and repetition). Seen from this angle, physics, chemistry and biology are intent on recapturing the transversalized indiciality of a technicized environment through the coordination of progressively more powerful indexes, thus within a diagrammatization and mathematization that wants to be as comprehensive as possible.

What is remarkable about photographs, as slightly and possibly indexed photonic indices, is that they take up the anthropogenesis we have just been sketching, which, incidentally, will be further explored in my work on anthopogeny (www.anthropogeny.be). Painting, sculpture, literature, and even music push us (in an illusory fashion) to approach things directly from the climax or the ending, thus from fully calculated signs, while discarding indices and indexes, as well as the indicial technique, as merely subaltern phenomena. Generally speaking, philosophy has forgotten these phenomena, much in the same way it has forgotten the photograph. However, photography continuously confronts us with the inverse anthropogenic situation, which holds that one must *first* cope with an environment through segmenting, comparing, exchanging, transversalizing, possibilizing, indexing, and indicializing it. All this takes place amidst still highly active perceptual-motoric and logical-semantic fields. *Only subsequently and episodically* will things be represented more extractively and abstractively through full analogical and digital signs (with determined referents), which gives us the illusion that they suffice to encompass the World, which has become nothing more than a simple Referent of which we are now its creators and demiurges. The Platonic and Kantian conception at the basis of mathematics is the culminating point of this pretense, whereas its general coordination of concrete indexes and its subsequent abstract indexations explain both its labored historicity and the permanence of its knowledge – in short, the construction of its transcendental status.

(Just to note in passing, our definition of mathematics as the practice of the general *coordination* of indexes, or rather indexations, kills several birds with one stone. Besides possibly elucidating the simultaneously exact and still somewhat magical or mystical status of mathematics (nothing is more precise, magical and mystical than an empty referential sign), our definition renders the index (unlike the indicial) in photography or elsewhere, a huge and ordered field whose virtualities mathematics has explored for centuries, rather than just a general term. On the other hand, in face of the pure index understood as the preeminent *coordinable*, art detaches itself as the (rhythmic) *compatibilization* of

the *in-coordinable*. It would then be necessary to verify whether it really are the indexes and indices which manipulate the mathematician. One could become more receptive to this idea after perusing the elementary but abundant mathematical "objects" collected in Hugo Steinhaus's *Mathematical Snapshots*, and its subsequently revised editions starting with the 1938 version published by Oxford University Press up to Flammarion's 1964 translation entitled *Mathématiques en instantanés*. The book speaks exclusively of directions, markings of origin and finality (ordinality), small quantities and collections (cardinality), rotations (modulo), projections, lateralizations (left, right), routes-paths, and so on, rather than addressing measure, which is merely a particular case. We still need to make sure that sophisticated mathematics plays with similar but more refined and generalized "objects". In any case, the sister of mathematics, formal logic, breathes the same atmosphere, especially considering the name Spencer-Brown uses for his system, i.e. the *logic of indices*.

Furthermore, anthropogenesis, which tirelessly leads us back to the photograph, not only provokes modesty, but also induces a better understanding of our loftiest achievements. Everywhere, the position of genius was a restoration of initial anthropogenic stages, regardless of whether it concerns a Pre-Socratic philosophical text, Riemann's mathematics, a pen stroke by Mozart or Proust, or a photo by Stieglitz.

Lastly, and with respect to a fundamental anthropology, photography will undoubtedly lead us to a final conversion by encouraging us to get past the West's primary and traditional categorization in terms of *world – consciousness* in order to adopt a categorization more suitable to our new situation in the Universe, i.e. *functionings – presence(s)*. Once freed from the presumptions which unduly privilege fully referential signs, an act which ultimately pits Consciousness against World, one would perhaps be more willing to see that, from start to finish, the Universe is surely nothing more than (describable) functionings and (indescribable) presences. These two irreducible orders are what Latin, Christian, Cartesian and Sartrean *con-scientia*, in response to rational craftsmanship and also to initial industrialization, believed would merge, over two millennia, to form a "freedom" paradoxically conceived in terms of making-present functionings as well as functioning presences, and whose aporias have already been examined by Kant (The categorization functioning/presence(s), together with its principle moments, has been defined by the author in *Les philosophies du temps*, published by the Brussels Centre for Fine Arts in 1983 in the catalogue "L'art et le temps").

By virtue of the anthropogenic anteriority it grants to indices and indexes photography is more presential than consciential and to a certain extent frustrates the pretensions of creation and pure freedom of the classical "conscience", For this reason, photography is still the most philosophical object, or rather process, there is.

The suppression of "Questions of method" should not distract us from what is most essential. I would like to thank my colleague and Agfa engineer Roger Huybrechts for his always elucidating responses. I would like to finish with this book's dedication, which, thanks to its dissimulation, is all the more sincere: IN LOVING MEMORY OF ROBERT CAPA.

APPENDIX

PEIRCE AND PHOTOGRAPHY

When discussing the theory of photography, great merit is accorded to the "index according to Peirce". Or, inversely, photography is illuminated to such an extent by the semiotics of the American philosopher that it must be the instance revealing certain shortcomings of the theory. As the six volumes of Peirce's 1930 *Collected Papers* are not readily available, we will cite from the excellent selection of texts by Justus Buchler in the *Philosophical Writings*, published by Dover in 1940. Emphasis is mine.

First and foremost, photographs as signs are ICONS (104-7), that is to say images or resemblances, which, to the scientist Charles Sanders Peirce, seem "very instructive" (106) and "highly informative" (119); "in certain respects they are exactly like the objects they represent" (106). However, even faithful iconicity does not at all imply *existence* in the Peircean sense. It is a *quality* captured as a pure possible (80-87), as *Tone,* a monadic relation (92), Firstness (80-87), the field belonging to artists, according to *potential mood* (111).

But photographs as signs are also INDEXES (107-11), understood in terms of what we have been calling INDICES, which are linked through physical and causal relations between their objects: "they are *physically forced* to corresponds *point by point* to nature" (106), and "the fact that it is *known* to be the *effect* of the radiations of the object renders it an *index*" (119). Peircean indexicality pertains to Secondness (87-91), the domain of the pure event, the *Token* (mark), to the action-reaction in a dyadic relation (92), to "struggle", *existence;* it is the field belonging to businessmen, power and education, in accordance with the *imperative* or *exclamatory mood* (111).

In addition, Peirce also distinguishes a third category of signs, i.e. SYMBOLS (112-5), which suggest a "law" and which lead to the "argument" (93), to inference, and to the triadic relation, of which Peirce the logician remarks that they can only be obtained from monads and dyads, as well as engendering all other types of relations (tetradic, pentadic and so on). This is the field of Thirdness (91-93), of *Type,* the field of the scholar. It is therefore Peirce's field, where *Reality* stretches out, where objects reticulate into a World thanks to a "fallible" Inquiry, in accordance with the *declarative mood* (111), while meeting the "pragmaticist" criterion: "I do not reason for the sake of my delight in reasoning, but solely to avoid disappointment and surprise" (125). Thus, Peirce's God is *real* without *existing* (375-378), visible to the eye and heart: "as to God, open your eyes - and your heart, which is also a perceptive organ - and you see him" (377). Do photographs partake of Peircean *reality*? He notes that he privileges "Dicent Sinsigns", which comprise "weathercocks" (115, 119, 234) but also photographs which, as he tells us in passing (119), are a "mode of combination, or Syntax" of iconicity and indexicality (115), which "must be also significant" (116).

In any case, with Peirce it is never the case that this or that sign is wholly an icon, an index, or a symbol. In the majority of his examples, the same sign can be an icon from one perspective and an index from another, while being a symbol from yet another angle, while all of these aspects are in themselves still "of a peculiar kind", depending on whether other "respects" interact. In brief, Peircean classifications are directed towards *formal objects* rather than *material objects* in the scholastic sense. This stems from his "Synechism", or the continuous coherence of all things. Expressing his fondness for John Duns Scotus, he writes: "I am myself a *scholastic realist* of a somewhat extreme stripe" (274).

Peirce agrees that his semiotics is complicated, and sometimes inextricably so: "It is a nice problem to say to what class a given sign belongs" (119). But his statistical fallibilism reassures him: "But it is seldom requisite to be very accurate; for if one does not locate the sign precisely, one will easily come near enough to its character for any ordinary purpose of logic" (119).

Let us return to photographs. They have already been ranked as ICONS. However, this qualification is really too broad since it not only applies to traditional paintings, ideographs, diagrams, but also to algebraic equations: "an algebraic formula is an icon" (105-7); and even to sentences: "the arrangement of words in the sentence must serve as Icons, in order that the sentence may be understood" (CP: 4.544).

In addition, more serious problems arise when Peirce categorizes photographs among INDEXES. It is necessary to point out, in order to fully realize the stakes, that French, and Romance languages in general, differentiate between *indices* and *indexes* – a distinction which we have tried to preserve in the English version of our text. According to this differentiation, INDICES are the effects signaling causes, thereby revealing these causes. As they are non-intentional, INDICES predominantly travel from the subject towards the object. On the other hand, INDEXES are caps which, because of their intentionality, start out from the subject towards the object. In our *Philosophy of Photography*, photographs can therefore be defined quite rigorously as *possibly indexed indices*. *Indicial* then refers to the natural and technical aspects of photonic imprints, while *indexical* refers to the side of the subject (the photographer) who chooses his frame, film, lens, developers and prints. In *Logiques de dix langues européennes*, we have offered some explanations as to why English does not normally differentiate between indices and indexes, and usually only uses *index* (and its plural *indices*).

However, what is most disturbing is not the fact that, as an English speaker and a logician who should not have succumbed to this confusion, Peirce covers two divergent meanings (indices/index) with one word. Rather, what is most striking is that in the end, Peirce only acknowledges indices (in the sense we have just explained), which he then groups under the name of index wherever he finds them. As such, Peircean INDEXES, which are synonymous with our INDICES, simultaneously cover: 1) *indices*, such as thunder or imprints, thus also including photographs; 2) *linguistic indexes* such as *possessive pronouns* ("a possessive pronoun is in two ways an index" 110), as well as *relative* and *demonstrative pronouns* and *quantifiers* ("quilibet, quisquam, quidam," 111); 3) *propositions*: "a Dicisign necessarily represents itself to be a genuine Index, and to be nothing more" (CP, 2.310), given that "every kind of proposition is either meaningless or has a real Secondness as its object" (CP, 2.315); 4) *the names*

PUT THE 50 MOST FAMOUS PHOTOGRAPHERS TOGETHER
AND ALL YOU GET IS SHIT

PHOTOGRAPHY IS MERELY A CHEAP REPRODUCTION OF REALITY

of existent things once they are uttered or written: "A Replica of the word 'camel' is likewise a Rhematic Indexical Sinsign, being really affected, through the knowledge of camels, common to the speaker and auditor, by the real camel it denotes" (117); 5) *the uttered or written names of imaginary things*: "The same thing is true of the word 'phœnix'. For although no phœnix really exists, real descriptions of the phœnix are well known to the speaker and his auditor; and thus the word is really *affected* by the Object denoted" (117).

Accordingly, two serious flaws arise when dealing with photography: 1) the notion of the Peircean INDEX (as the INDICIAL) is really too broad as it encompasses virtually every sign as seen from differing perspectives. 2) Peircean indiciality ("to be affected by") is often tenuous because it is reduced to a cerebral action, which is inadequate when considering the physicality of the photograph. This also instills a gap, because a full consideration of the tension between indices and indexes would have led Peirce to realize that the inherent logical operations in the "reading" of photographs illustrates his third inference remarkably well, i.e. the inference which he calls abduction or retroduction (150-6), in addition to deduction and induction. Finally, allowing a momentary venture outside the domain of photography, an adequate differentiation between indexes and indices would undoubtedly have prompted him to characterize Mathematics, which is one of his major concerns, as the *general coordination of indexes* rather than a "method of drawing necessary conclusions" or the "study of hypothetical states of things", as formulated by the doctrine of his father, the mathematician Benjamin Peirce (135-49). In addition, he would also have realized that Physics is the *general coordination of indices within this general coordination of indexes*. However, Peircean Synechism leads one to reduce indexes to indices. Peirce himself pointed out on numerous occasions that philosophers invariably prefer coherence over the truth (5-59).

One can only wonder why so many of our contemporaries are so infatuated with the "index according to Peirce". Even here Peirce the semio-sociologist comes to our aid by underlining at length (5-59) that, for reasons of academic conviviality, a vague idea and a white lie are more lucrative than clear and distinct ideas. It is the same fuzziness which, in the wake of Roland Barthes's texts, has undoubtedly been enhanced through things like the "message without code", which is a contradiction in terms; through the *ça-a-été*, the *having-been-there*, whose "ça" or present perfect one can hardly locate precisely; through the "punctum/studium", which the majority of eminent photographers had already dismissed; through the bombast of "it is Reference, which is the founding order of Photography", even though indices 'bring' or 'bear', from the Latin verb *ferre*, but do precisely not *re-fer*, they carry but do not point, they signal but do not designate unless they have been forged by murderers or thieves and therefore have become indexes; through the constant mixing of real and reality, which is the most convenient tool of any photographic aesthetics, while ignoring the differentiation between Reality and the Real, as well as that between World and Universe; through the phrase "the thing has been there", whereas a photograph so eloquently testifies to the fact that there are so very few "things", and only instances-states within the general flow of the Universe; through "unutterable singularities", whereas every singularity is but a possible or an illusion (of memory) as Peirce illustrated perfectly in 1868

in his seminal profession of anti-Cartesian faith entitled *Some consequences of four incapacities* (later, Peirce would describe the interpretant-interpreter as "a quasi-mind", "a person" and "a sop to Cerberus, because I despair of making my own broader conception understood").

One must understand that our reservations regarding Peirce on the specific theme of photography are amicable exigencies, since I share, implicitly but always expressly since *L'Animal signé* (1980), the fundamental tenet of Peirce as well as Aristotle, that, in epistemology, one should always start out with the Object in order to reach the Sign, and not inversely. Even an index, which goes from Sign to Object *in a very near future*, travels from Object to Sign *in a distant future*, as Peirce already, and rather too strongly, maintained. However, for Saussure, the contemporary of Emst Mach and the hardliner of the "arbitrariness of the sign" (following William Dwight Whitney, 1875), the Object slips into the status of a simple Referent, which one will deal with later, even if it means one can never recapture it in a truly upside-down epistemology.

Thus, if "indices" are opposed to "signs" in my *Philosophy of Photography*, it is only because of a nominal definition that is capable of emphasizing the sharp contrast between *non-intentional* photonic imprints, pictorial *intentional* touches and their own equally *intentional* indexes. This is important when keeping in mind the differentiation between 'signaling' and 'designating', as indices signal and all other signs designate. However, it goes without saying that, as my publication *Fundamental Anthropology* demonstrates, indices form part of the order of Signs (fever is the "sign" of an infection, and it has initiated "semiology"). Signs are even the first movements of the basic anthropogenic suite of Indices-Indexes-Paintings-Figures. However, even in this theory of photography, it would perhaps have been better had we continuously employed the language of my *Fundamental Anthropology,* no matter how laborious it may be and regardless of whether it would cause discomfort to some readers, as with the nominal definitions we advocated forcefully in the second chapter of this book. The well-trained scientist that he was, Peirce was too confident to be capable of believing that nominal definitions are always legitimate, and also occasionally economical.

Image p.119,120: Jamez Dean, *Untitled*.

PHOTOGRAPHERS

FEDRA DEKEYSER

In the work of Fedra Dekeyser the human presence in landscape functions as an anomaly. With her tongue in her cheek she wanders around 'forgotten' tracts of land in suburbia. Carefully framed fragments of houses, gardens, nondescript warehouses and factories are lifted out of their everyday context, resulting in a 'collection of absurdities'.

ARNAUD DE WOLF

Arnaud De Wolf focuses on human interventions in the landscape, and their side effects. In his purified and pictorial images the human being is absorbed by the mass and therefore is never fully present as individual. In his recent work, De Wolf plays an interventionist role, imposing minimal sculptures upon the landscape, and integrating photos and videos in site-specific installations.

ESTHER EGGERMONT

The city is Esther Eggermont's hunting ground. She tracks conformities and codes of conduct in public spaces. Presenting a kaleidoscopic collage of rather small, stylized, black and white images, she reconstructs feelings of enchantment within a crowded city. Not yet having been given a narrative frame, and having lost its functional and photogenic nature in this setting, the human subject becomes merely a pawn.

BRITT GUNS

Britt Guns questions the authenticity of images. Mixing manipulated and straight photographs, she blurs the boundaries of the real and unreal. Guns confronts the viewer with a new, constructed, factive reality. Inspired by mass-media techniques manipulating perception, for instance with reference to storytelling, she brings together her own photographs of appealing landscapes with scenes from different locations in the world. Drawing parallels between the vast openness of the Siberian Tundra, and the isolation and alienation to be found in the Western world, Guns presents The Blank Tarmac as an inner journey.

JAMEZ DEAN

"AS IT IS"

ROËN

In his image "Sarah's creek", Roën plays with expectations. The photographer is clearly not afraid of overt estheticism. The gaze is ambivalent and voyeuristic, the setting is idyllic. Still, at the same time the darker sentiment is apparent that it looks all too good to be true. For Roën, the fictive nature of

his images operates in a double fashion: it stimulates putting situations into perspective, and it has the ability to hold up a mirror. In this mirror, protagonists in desolate surroundings are conceived as nostalgic projections of their own minds and feelings.

BART MEYVIS

Both in his documentary about the Turkish community in Belgium and in 'Crazy people', a series of freewheeling youngsters, Bart Meyvis observes social behaviour and explores the possibility of creating realistic images of daily life. In the latter, switching between the traditional mode of reportage-photography and the method of active participation, Meyvis takes a closer look at the youth culture he inhabits.

SARAH MICHIELSEN

A sense of the uncanny prevails in the nocturnal cityscapes, the isolated human figures in urban settings, and the carefully observed interiors shot by Sarah Michielsen. The rather old-fashioned middle-class interiors possess a peculiar tactility: the materials and textures take on the quality of 'remembered' objects. In her static portraits humans appear as actors without discernable identity. Instead, the viewer is left with the possibility of projecting narratives and characters upon these figures.

ROEL PAREDAENS

Whereas his earlier work had a strongly documentary approach, the photographer is now taking on more abstract themes such as boredom and nothingness. His characteristic gaze is, however, as clearly present now as it was then: Paredaens has the ability to look at a very familiar thing, but still to seize the attention of his subject as though it were a first encounter. This contradiction in its interpretation goes to the core of his work, which is simultaneously unspectacular and discomfortingly strange. Paredaens is currently studying for a master's degree at the Royal College of Art, London.

STEFAN TAVERNIER

Stefan Tavernier's photographs function almost as a pretext. His real interest lies in designing 'experience locations'. Large monumental prints with different surfaces (touch – of skin and eye alike – is a capital sense for Stefan) form an installation where the individual is immersed in a virtual surrounding. His photographs often depict people in paradisial surroundings, sometimes with a slightly scary aftertaste. Ideally his works are to be installed in public spaces, so that viewers are confronted with his large-scale dioramas unexpectedly.

SARAH VAN MARCKE

In her photographic work, Sarah Van Marcke creates a cross-over between architecture and fashion design, bringing about a reflective world. Being transformed into photographic images and serving

as backdrops, existing urban or architectural sites seem to have lost both reality and functionality. Hence landscapes look like models in miniature, to which objects or bodies have been added as hidden or conspicuous sculptures.

SIMON VAN SNICK

The series is based on a strategy of creating images that seem over-mediated while keeping their photographic integrity and thus their claim to truth. Starting from a slightly queer manifestation that was conceived beforehand (in this case 10 pedestrians walking in a row without any overlap between them), the photographer mechanically multiplies the same image in different concrete settings. The images constitute an attempt to criticize, in an ironic and playful manner, the way photographic images recurrently position their viewer in a discourse of truthfulness, in a spontaneous and unseeing stance of "seeing is believing".

ALEXANDRA VERHAEST

The point of departure of Alexandra Verhaest's diptych "Madonna-Medea" is the question whether a sex worker still craves sexual fulfillment. Drawing on interviews with an escort lady, Verhaest in the first panel portrays an anonymous woman without erogenous zones: mouth and nipples are erased. The other panel shows a sterile, generic interior leaving the viewer with a feeling of loss and incompleteness.

THOMAS VERKEST

The basic assumption that one of the crucial – medium-specific – elements at play is time, lies at the heart of Thomas Verkest's praxis. In order to recreate 'evolving time' (la durée), Verkest pastes together several snapshots taken over the course of one day. Reading from left to right, the viewer is literally able to recreate both time passing and sunlight moving over a specific landscape.

TOM GOFFA

In his 'ideography' Tom Goffa raises issues such as 'artificial nature', alienation and dislocation. Mixing scale-modeling, 3D software and photography into a hybrid form, he is rather 'creating' than 'recording', hence maintaining control and keeping distance.

COLOPHON

© ACCP, 1983
© Henri Van Lier, 1983
© Les Impressions Nouvelles, 2006

© Photographs:
Fedra Dekeyser, Arnaud Dewolf, Esther Eggermont, Tom Goffa, Britt Guns, Jamez Dean, Bart Meyvis, Sarah Michielsen, Roel Paredaens, Roën, Stefan Tavernier, Sarah Van Marcke, Simon Van Snick, Alexandra Verhaest, Thomas Verkest

© 2007 by Leuven University Press / Universitaire Pers Leuven / Presses Universitaires de Louvain
Minderbroedersstraat 4, box 5602, B-3000 Leuven (Belgium)

ISBN 978 90 5867 598 9
D/2007/1869/18
NUR: 652

Final editing: Jan Baetens, Mieke Bleyen, Rein Deslé, Geert Goiris
Translations: Aarnoud Rommens
Proof reading: Paul Arblaster

Lay-out: Joke Klaassen

With the support of the Research Platform for the Arts, K.U.Leuven

Lieven Gevaert Research Centre
Arts Faculty K.U.Leuven
Blijde-Inkomststraat 21
B-3000 Leuven